LOWER MANHATTAN
THROUGH TIME

RICHARD PANCHYK

AMERICA
THROUGH TIME®
ADDING COLOR TO AMERICAN HISTORY

To the Fiat Café on Mott Street

America Through Time is an imprint of Fonthill Media LLC
www.through-time.com
office@through-time.com

Published by Arcadia Publishing by arrangement with Fonthill Media LLC
For all general information, please contact Arcadia Publishing:
Telephone: 843-853-2070
Fax: 843-853-0044
E-mail: sales@arcadiapublishing.com
For customer service and orders:
Toll-Free 1-888-313-2665

www.arcadiapublishing.com

First published 2017

ISBN 978-1-63500-046-7

Typeset in Mrs Eaves XL Serif Narrow
Printed and bound by CPI Group (UK) Ltd, Croydon, CR0 4YY

INTRODUCTION

As I was taking photos for this book, I passed a quaint, friendly restaurant in Little Italy that made me realize what I love most about Lower Manhattan. It's that cozy feeling of belonging to something intimate and vibrant; excitement combined with comfort. Whether South Street or Chinatown, Wall Street or Washington Square, there is a dynamic electricity that permeates its neighborhoods. Because of all its enticing attractions, Lower Manhattan is bustling and lively at practically any hour of the day. Pedestrians, cars, taxis, bicycles, and buses are the lifeblood pumping through the veins of the city's heart.

Maybe some of that feeling comes from the fact that Lower Manhattan is the oldest and most vital part of the city. The historic buildings and narrow streets lend a special intimacy. What began as a tiny Dutch settlement in 1626 at the very southern tip of Manhattan Island slowly expanded north. From the 1650s through the end of the 17th century, Wall Street marked the northernmost limits of the city. As the 18th century progressed, development continued, but by 1790, Varick and Houston Streets were still "country"—with great old oak trees, wild shrubs, and partridges, rabbits, and woodcocks roaming the area. When City Hall was built in 1811 just south of Chambers Street, it was considered on the edge of town. By 1828, development on Broadway only extended as far north as 10th Street.

The very concept of "downtown" and "Lower Manhattan" evolved as the city grew, just as have the concepts of midtown and uptown. Never mind downtown; when it was first populated in the early years of the 19th century, Greenwich Village was not even considered uptown, it was considered out of town. Though there are various interpretations of the northern boundary of Lower Manhattan, some beginning at Chambers Street, I am going with a broader definition that includes everything south of 14th Street, a length of a little more than two and a half miles.

Though all traces of the Dutch era have been obliterated, Lower Manhattan has some of the city's finest surviving early 19th century buildings, including Aaron Burr's carriage house. Lower Manhattan is also home to two of the city's oldest buildings—the largely reconstructed Fraunces Tavern (1719) and St. Paul's Chapel (1766), where George Washington worshiped.

While Lower Manhattan is home to major attractions such as Washington Square Park, the Freedom Tower, the National September 11 Memorial and Museum, South Street Seaport, and Trinity Church, it is also known for its uniquely colorful neighborhoods, some ever transforming, some very much the same.

Greenwich Village started as a refuge for New Yorkers fleeing north from yellow fever outbreaks in the 19th century, and in the 20th century became an edgy, bohemian place that was home to a wide array of quirky characters and stores selling unique clothing and alternative music. The latest iteration of the Village bears more resemblance to a cosmopolitan college town with chain stores and upscale, boutique shopping—still unique, but different.

Little Italy, meanwhile, formed to accommodate Italian immigrants and create a home away from home. That magical ambiance has been largely retained, along with many old buildings, and walking its streets is like being transported back in time. The neighborhood is a feast for the senses—the smell and taste of the flavorful food, the colorful sights, and the musical quality of sounds of Italian still being spoken.

In this book, we'll take a trip through time as we journey into the heart of the city, starting at 14th Street and working down toward South Ferry, pausing to make many stops along the way, grabbing coffee at a cafe in the West Village, window shopping in SoHo, and enjoying historical sights at the Seaport ...

Note: The images in this book are presented in geographical order from north to south.

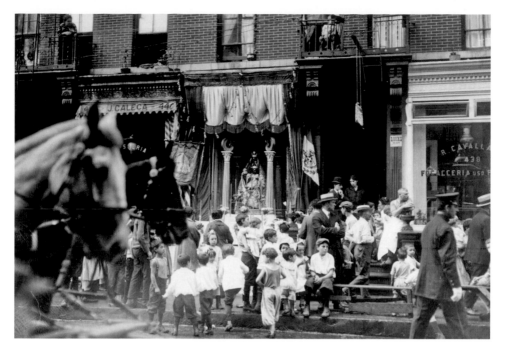

438-440 EAST 13TH STREET: Hundreds of years ago, a black wood statue of the Madonna and Child made its way to Sicily from the east, and the unique statue amassed a group of followers, who over the years created their own versions of the black Madonna. The Shrine of the Black Madonna in New York was founded by Sicilian immigrants in the early 20th century. The first festival was celebrated in 1905 on 12th Street, and then at several addresses on 13th Street, where there were small chapels dedicated to the devotion of the black Madonna. The chapel is long gone and the 13th Street statue is now in a private collection.

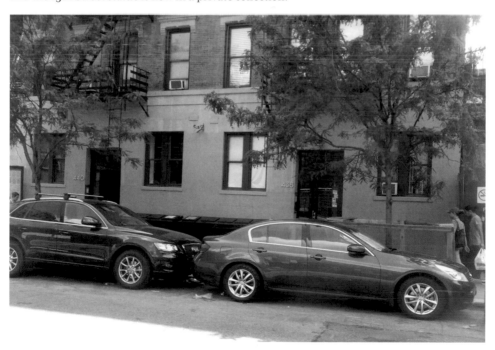

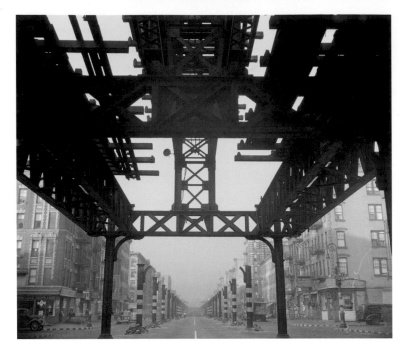

FIRST AVENUE SOUTH FROM 13TH STREET: The Second Avenue "El" (elevated train line) was one of several that ran north-south in Manhattan. First opened in 1880, the Second Avenue line (which went from South Ferry to Second Avenue and 65th Street) actually ran along First Avenue south of 23rd Street. The elevated train was certainly a convenience for New Yorkers in places where there was no underground subway, but it came with a price. It was unsightly and noisy, and kept the street below in shadows all day long. The Second Avenue line was demolished in 1942 and today not a trace of it remains.

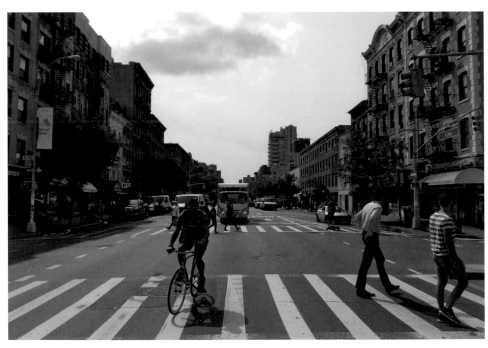

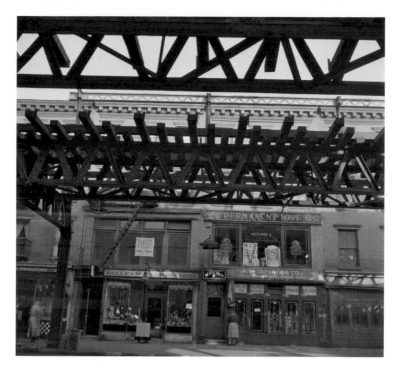

First Avenue between 13th and 14th Streets: The demolition of the elevated line must have seemed quite strange for those residents and business owners who had spent their whole lives in the shadow of the tracks. The buildings that stood when the El was removed are still there today, though their facades have been altered. Note the presence of three eateries along the strip in the current photograph; there are far more restaurants in Manhattan today than there used to be, as eating habits have changed over the years.

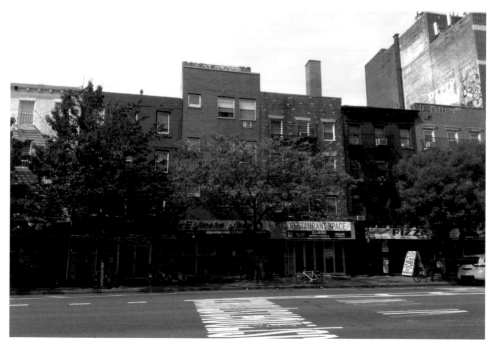

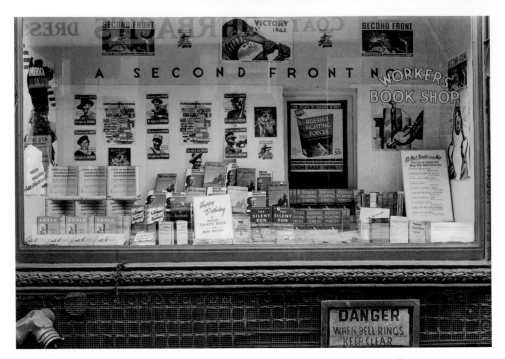

48 WEST 13TH STREET: The 1943 image seen here shows a workers' bookshop in a building on 13th Street between University Place and Broadway, which was for some time the headquarters of the Communist Party of America. A 1934 press photo describing the activities of its tenant called it a "rather tawdry building." It was also home to the New York Workers School, which taught communist ideas. There is one piece of evidence that remains today of the building's controversial past; above the door are the branches that were part of the symbol of the Communist Party of America.

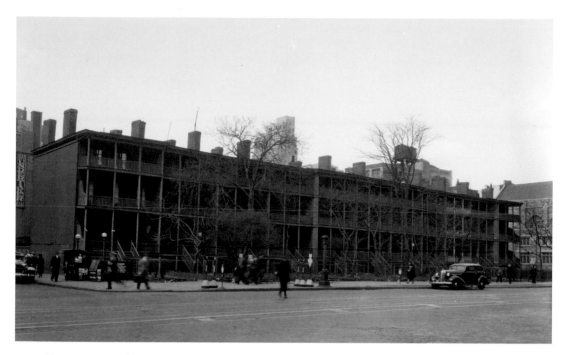

RHINELANDER ROW: This row of houses on Seventh Avenue between 12th and 13th Streets, captured in a 1936 photograph, was demolished in 1937. Built by William C. Rhinelander in 1849, these brick homes were on the west side of the avenue. The buildings were set back 40 feet off the street. They had a unique appearance with their front porches on all levels. The homes had many monikers over the years, including Cottage Row, Honeymoon Row, Cottage Place, and Grapevine Cottages. The building which now stands in place of the Row was originally the National Maritime Building (built 1964) but has since been transformed into the Phyllis and Leonard Hill Pavilion of the Lenox Hill Healthplex.

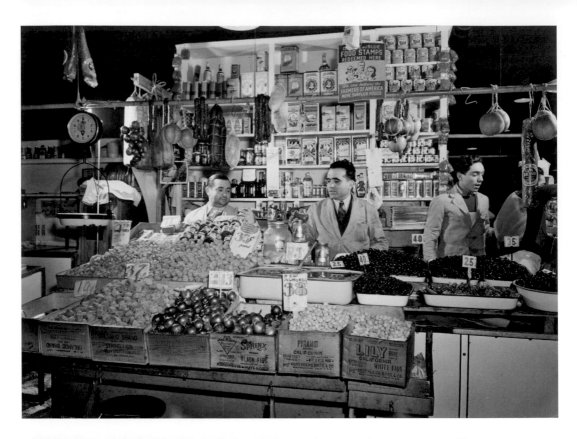

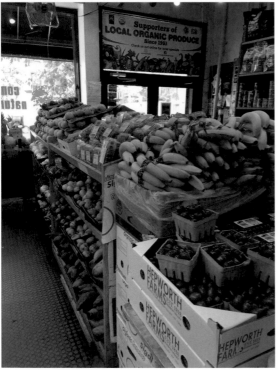

GROCERY STORES ON EAST 10TH STREET: At the time the top photograph was taken in 1943, supermarkets were not yet a phenomenon. Lower Manhattan residents shopped at small grocery stores like the Italian market shown here, which were generously scattered throughout. Today, there are several supermarket chains with stores located in Lower Manhattan, including Gristedes and Associated, but that has not spelled the end of the small grocery store. The convenience of the local grocer is hard to resist for a small shopping trip.

ST. MARK'S IN THE BOWERY: Located at 131 E. 10th Street, this Greek Revival-style church was built in 1799 on property owned by the famous Stuyvesant family. The Stuyvesants constructed a chapel on the site in 1660, and when former governor Peter Stuyvesant died in 1672, he was buried in a vault under the chapel. The property was sold to the Episcopal Church for $1 in 1793. The cornerstone for St. Mark's was laid in 1795, and the church was completed in 1799. A fire in 1978 damaged the church; its restoration was completed in 1986. Notables buried in the churchyard include Daniel Tomkins (vice president under James Monroe), and Philip Hone (mayor of New York).

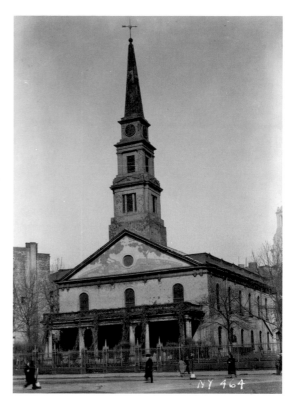

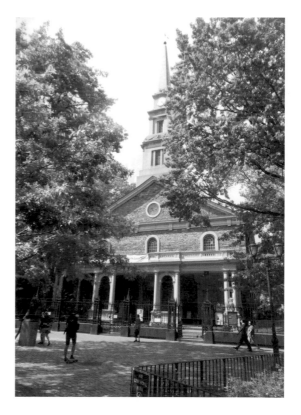

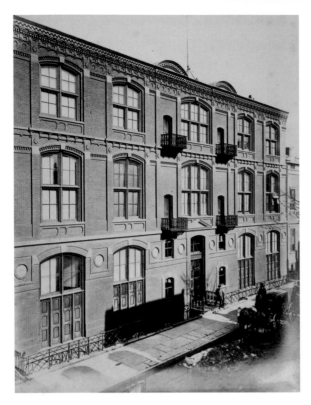

51 WEST 10TH STREET: The Tenth Street Studio Building on West 10th Street was designed by Richard Morris Hunt and completed in 1857. The building was a first—it was entirely devoted to art and artists. There were 23 studios as well as an exhibition room and several smaller rooms. The building's studios were highly sought after, and renowned artists such as Frederic Church, Winslow Homer, William Merritt Chase, and Albert Bierstadt painted there. It was demolished in 1956, replaced by an apartment building.

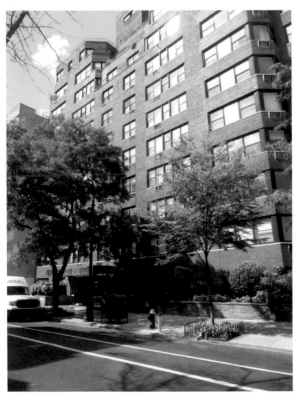

109 UNIVERSITY PLACE:
The New York Society Library was formed in 1754, and received a charter from King George III in 1772, in the era before public libraries. It had various locations downtown, including 33 Nassau Street and Leonard Street and Broadway. In 1856, the library moved to 109 University Place. In 1932, membership cost $12 per year and was limited to those recommended by members or those listed in the Social Register. In 1937, it found a new home uptown. The University Place building has since been demolished, and apartments were erected in its place.

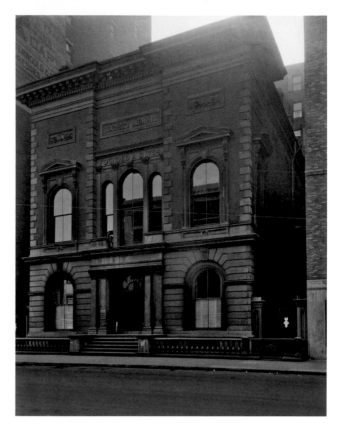

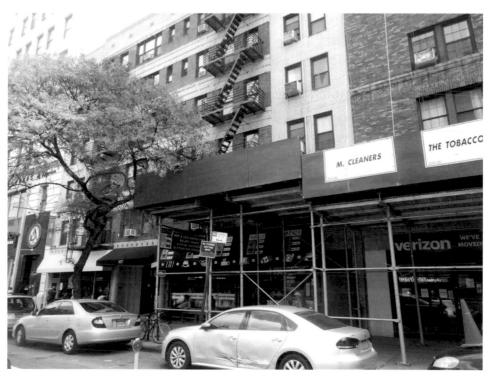

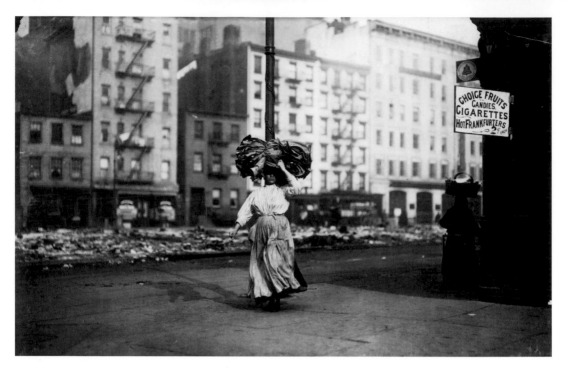

NEAR ASTOR PLACE: Like many parts of Lower Manhattan, the area near Astor Place has changed a great deal in the last 100 years. In the old image seen here, a young woman carries a bundle of fabric from a factory to be sewn and finished into clothing at home. The photograph was one of several similar images taken by Lewis Hine near Astor Place in 1912. Hine was an investigative photographer for the National Child Labor Committee and documented the working and living conditions of children.

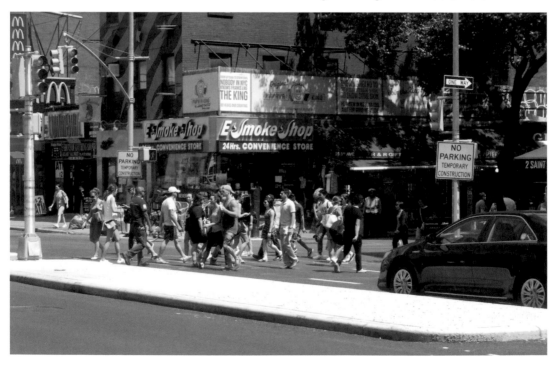

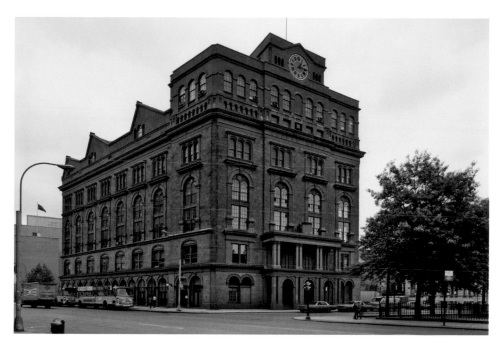

COOPER UNION: The Cooper Union for the Advancement of Science and Art was established in 1859 by Peter Cooper, who made it free to attend and opened it to both men and women. While the school has since expanded, the building seen here is the original, known as the Foundation Building (located between East 7th and 8th Streets and Third Avenue and Cooper Square), which contains the famous Great Hall in its basement. The school quickly made a name for itself after Abraham Lincoln, who was running for president, gave a major speech in the Great Hall there in 1860. Over the years, numerous notables have spoken there, including future presidents Grant, Cleveland, Taft, and Theodore Roosevelt, as well as presidents Wilson and Obama.

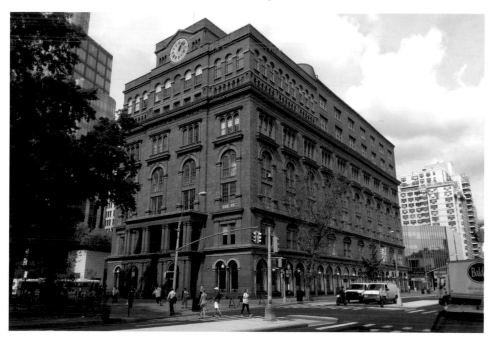

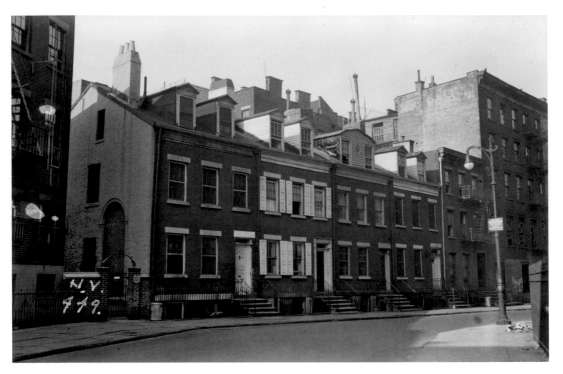

4-10 GROVE STREET: These quaint row houses in the West Village were built in 1829. In the 1930s, the basement of No. 4 featured a dining room and kitchen, the first floor a front parlor and back parlor, and the second floor two bedrooms, with extra room for use in the attic. Just down the street is 17 Grove Street, built in 1822, one of the few wooden houses still left in Manhattan.

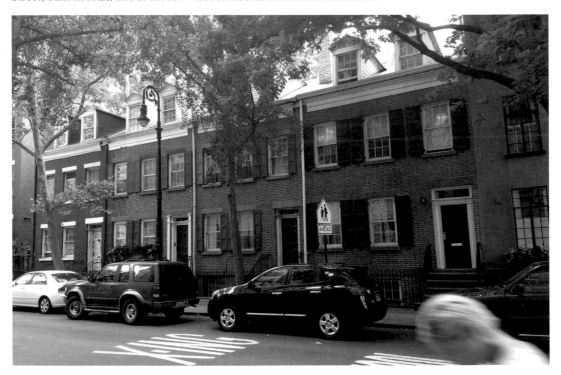

NORTHERN DISPENSARY:
This triangular-shaped
building at 165 Waverly
Place (at Christopher and
Grove Streets) has a long and
fascinating history. When it
was built in 1831, its restrictive
deed stated that the property
should be used to provide
medical care for the poor.
Records show that local
resident Edgar Allen Poe was
treated there for a cold in 1837.
It later served as a dental clinic
and was eventually owned by
the Roman Catholic Diocese
of New York before being sold
to developer William Gottlieb
in 1998. It now sits vacant,
awaiting its fate.

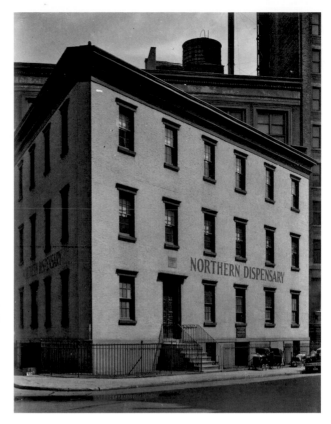

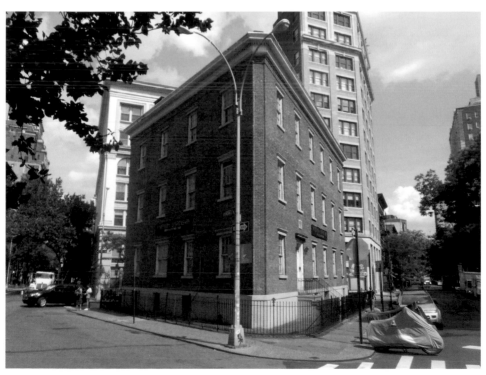

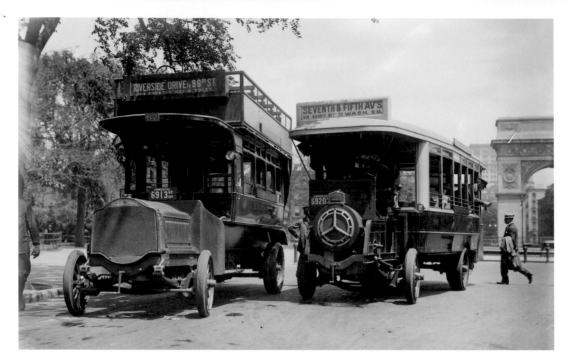

Buses on Fifth Avenue near Washington Square Park: Throughout the last 100 years—despite the presence of a wide variety of transportation options including streetcars, elevated trains, subways, taxis, automobiles, and bicycles—buses have remained a popular option. Though sometimes downtown traffic can be nightmarish, buses can be the quickest way between two points for those who know the city. These days, sightseeing buses are nearly as common as city buses, offering tourists a chance to see the sights in an easy, efficient way.

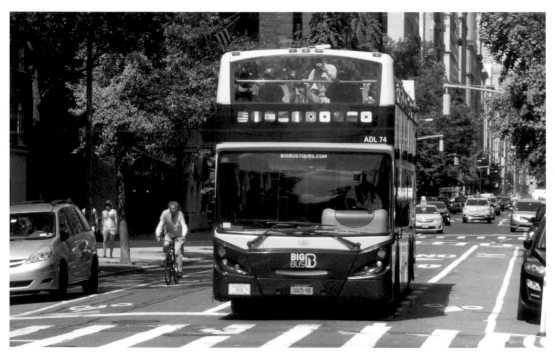

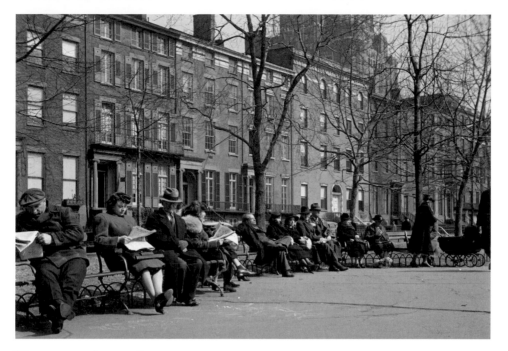

WASHINGTON SQUARE PARK: The park originated as formal parade grounds in 1827, when the 10 acres that had formerly been a potter's field (which was levelled, filled in, and abandoned in 1823) was surrounded with a wood fence. Moreover, paths were created and trees were planted. Though fashionable homes sprung up all around the square as a result, it did not truly become a park until 1870, when more extensive landscaping created the cozy neighborhood park that exists today. Locals and visitors alike love to use the benches to sit in quiet contemplation, or perhaps talk to their friends and neighbors.

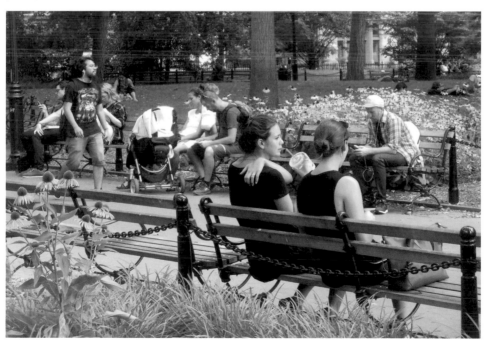

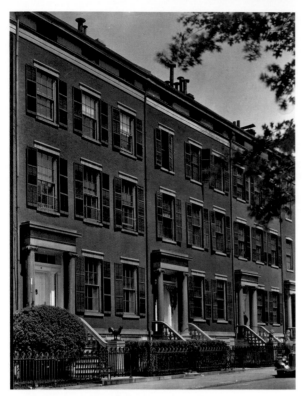

7 AND 8 WASHINGTON SQUARE
NORTH: The park and its surrounding
neighborhood were immortalized in
the 1880 novel "Washington Square"
by Henry James, which was made first
into a Broadway play and then into
a film called "The Heiress" in 1949,
starring Olivia de Haviland and Ralph
Richardson, and again in 1997 as the
film "Washington Square" starring
Jennifer Jason Leigh and Albert Finney.
The book reflected the prestige of the
neighborhood, as seen in the fine
homes that surrounded it. A number
of these 19th century homes, especially
along Washington Square North, are
still extant today. Number 8, shown in
these photographs, was built in 1833 by
the first president of the Metropolitan
Museum. It was at one time the site of a
pottery museum, opened in 1904 by its
then-owners, the de Forest family.

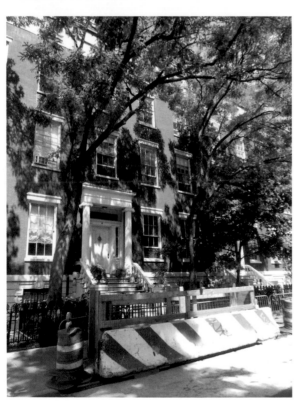

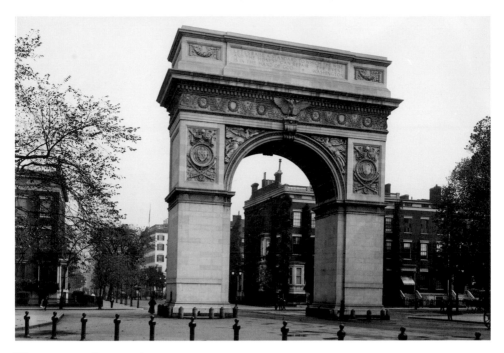

WASHINGTON SQUARE ARCH: Though it is hard to imagine Washington Square Park without its iconic arch, the legendary structure was only completed in 1892. It was designed by Stanford White, whose architectural touch graces so many of New York City's buildings. The marble arch at the Fifth Avenue entrance to the park replaced a wooden one that had been erected in 1889 to commemorate the 100th anniversary of George Washington's inauguration in New York City as the nation's first president. One of the inspirations for the arch was the Arc de Triomphe in Paris. A restoration of the arch was completed in 2004.

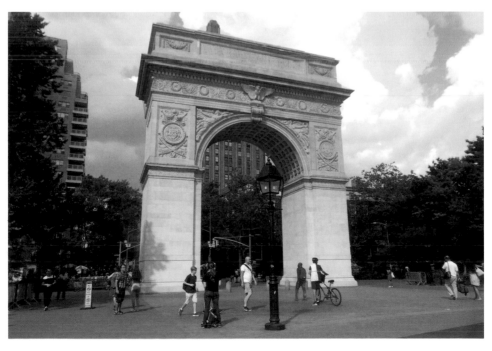

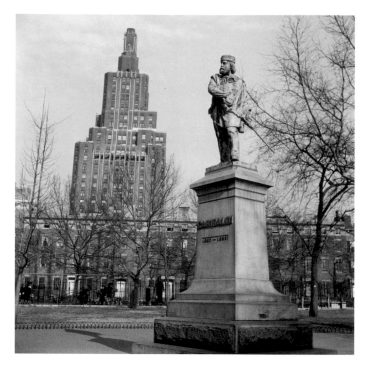

GARIBALDI STATUE: This larger-than-life bronze statue of Italian hero Giuseppe Garibaldi has graced the east side of Washington Square Park since 1888. The sculptor, Giovanni Turini, had met Garibaldi in 1866. The piece, on a granite base, was cast in the Lazzari & Barton foundry in Woodlawn, New York. When the monument was moved 15 feet in 1970 to allow for park improvements, a time capsule with newspaper clippings from the 1880s was discovered under the base.

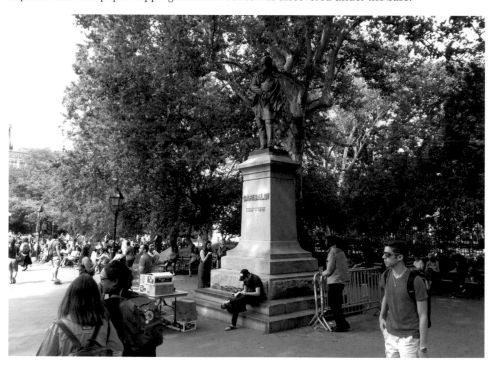

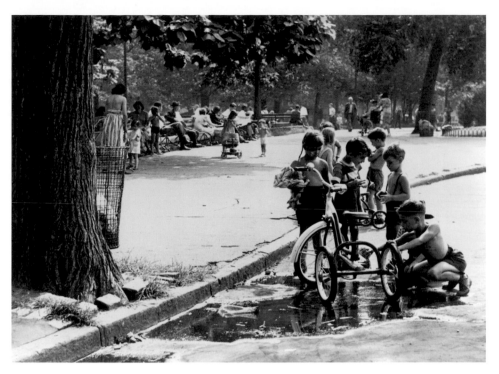

PLAYING IN WASHINGTON SQUARE PARK: With residential neighborhoods adjacent to the park, there are plenty of families in the area. Its wide open spaces make Washington Square Park a very popular place for local children to frolic and play. The fountain makes for a refreshing treat on a hot summer day. Built in 1960, the fountain is on roughly the spot where a gallows stood until 1820.

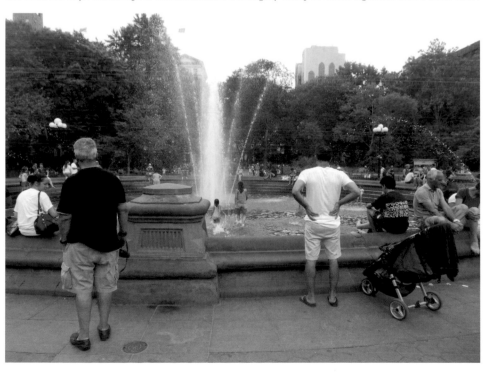

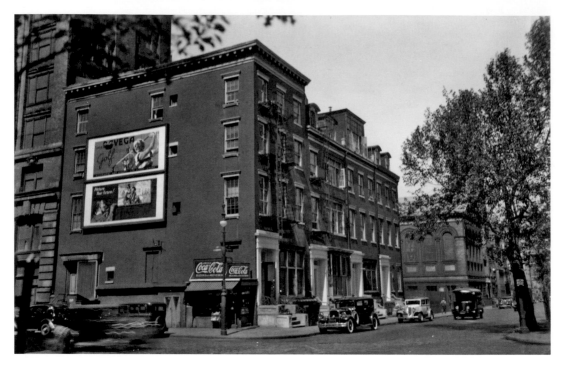

61 WASHINGTON SQUARE SOUTH: This land was originally part of the Ebert Herring Farm in the 18th century. It was subdivided into lots in 1826, and a house built in 1832 by John Noble. By 1936, when the image above was taken, the house was listed in poor condition. The house, and its neighbors, have been replaced by NYU's 230,000 square foot, 10-story Helen and Martin Kimmel Center for University Life, which opened in 2003.

29 EAST 4TH STREET: This brick house located near Washington Square Park was built in 1832 and purchased by a merchant named Seabury Tredwell in 1835. It was occupied by the Tredwell family for nearly 100 years before becoming a museum in 1936. Known today as the Merchant's House Museum, the building was designated as a New York City Landmark in 1965 (among the first 20 buildings thus designated by the Landmarks Commission), and its interior separately as a landmark in 1981. More than 100 pieces of Tredwell family furniture still remain in the house.

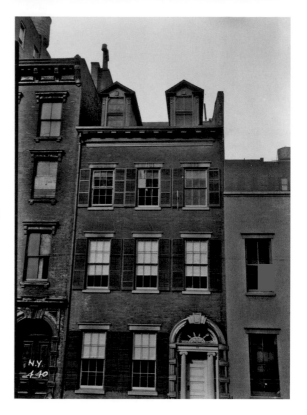

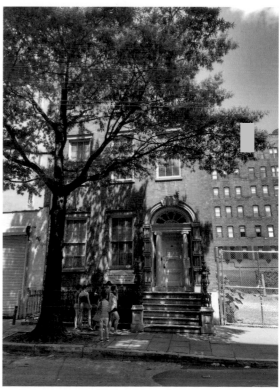

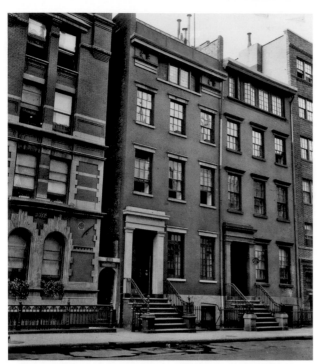

132 WEST 4TH STREET:

The four-story brick Greek Revival-style building at 132 West 4th Street was built in 1839. Originally part of the Thomas Ludlow farm prior to 1805, the property changed hands eight times in the next three decades before winding up the property of Alexander Masterson and Robert Smith, who built the house. The Historic American Building Survey notes recorded in 1937 mention how old New York houses are being altered into numerous small apartments. "While this may seem something of a come-down from the large commodious dwelling it once was, it is nevertheless so that old houses in their altered state afford rooms of considerable dignity which are easy to decorate and are comfortable."

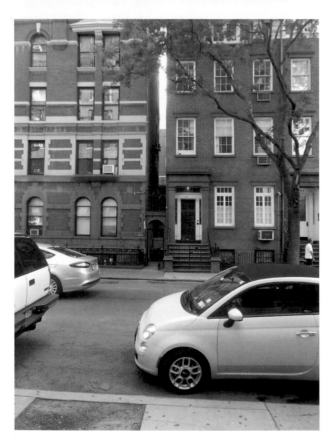

GRACE CHURCH: Grace Church was originally located in a building built in 1808 at Broadway and Rector Streets, near Trinity Church. In 1846, this Episcopal church moved uptown to its current location at Broadway and 4th Street, to a Gothic building designed by the 24-year-old architect James Renwick, destined for future fame but at this point very early in his career. A rectory was added in 1847. In 1863, Grace Church was the site of the wedding of Tom Thumb and Lavinia Warren. During the 19th century, Grace Church had chapels built on East 28th Street and at two different locations on East 14th Street. Restoration work on Grace Church since the early 1990s has included reconstruction of some stonework, and the dismantling and reconstruction of the top 30 feet of the stone spire, which was determined to be leaning slightly.

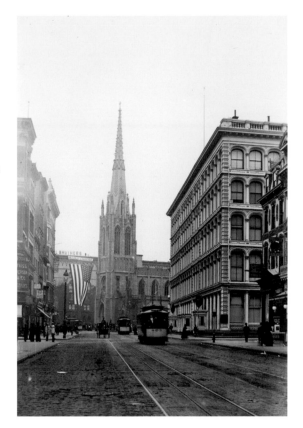

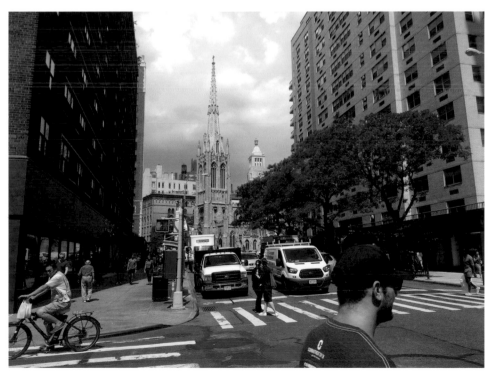

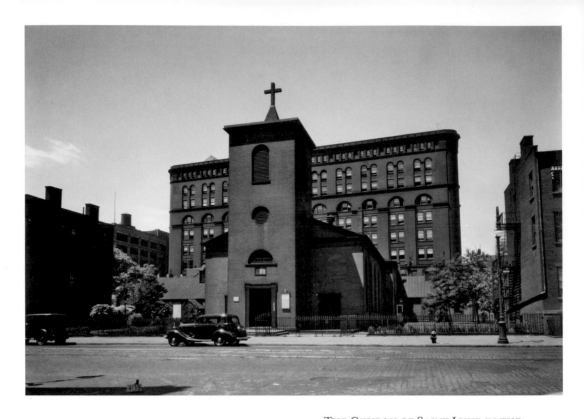

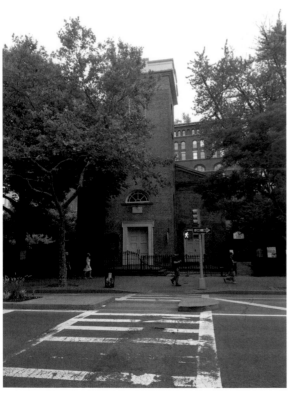

THE CHURCH OF SAINT LUKE IN THE FIELDS: One of the founders of this Episcopal church on Hudson Street between Barrow and Christopher Streets was local resident Clement Clark Moore, the future author of the poem "A Visit from St. Nicholas." The cornerstone was laid in 1821 and the church was consecrated the following year. In 1891, St. Luke's became a parish of Trinity Church, but in 1976 it became an independent parish once again. In 1956, a school and gardens were built adjacent to the church on the north side. A fire in 1981 caused major damage and the church had to be rebuilt, reopening in 1985. The church has been a refuge for those affected by AIDS since the start of the pandemic in the 1980s.

MOTT AND HESTER STREETS:
The corner of Mott and Hester
is one of the most famous
intersections in Manhattan. It is
the site where Italian immigrants
Giuseppe and Carmela Siano set
up a pushcart in 1894, offering
clams, mussels, and scungilli.
By 1904, they had expanded
the business into a storefront
at that location, opening up
Vincent's Clam Bar, today known
as The Original Vincent's (the
Long Island location is known
as Vincent's Clam Bar). The
restaurant has fed numerous
celebrities over the years,
including Frank Sinatra, who
once made his own pasta in
Vincent's kitchen. In 1965, a
vendor named Charles Catalano
was captured on film selling
fish at the corner; today, the
intersection is free of pushcarts.

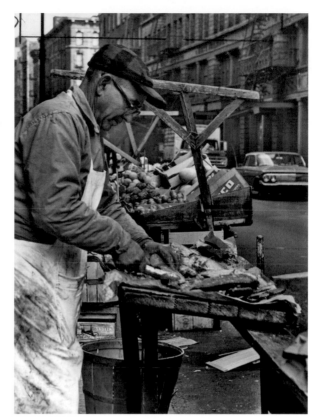

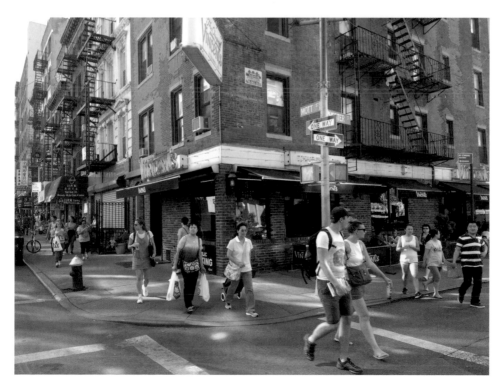

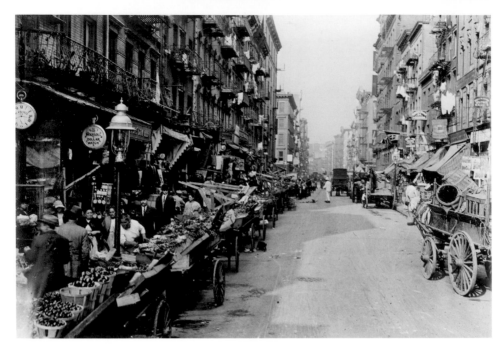

MULBERRY STREET: Running through the core of two of the city's most distinct and oft-visited neighborhoods, Mulberry Street offers the best of both Chinatown and Little Italy. In the past, it was crowded with pushcarts, residents, and shoppers, and the southernmost part of the street was especially dangerous and impoverished. The annual Feast of San Gennaro, which takes place every September, is centered on Mulberry Street and attracts thousands of visitors for a delicious immersion in Italian food and culture. The street was further immortalized in Billy Joel's song "Big Man on Mulberry Street" (1986), which also mentions Houston, Canal, Grand, and Hester Streets.

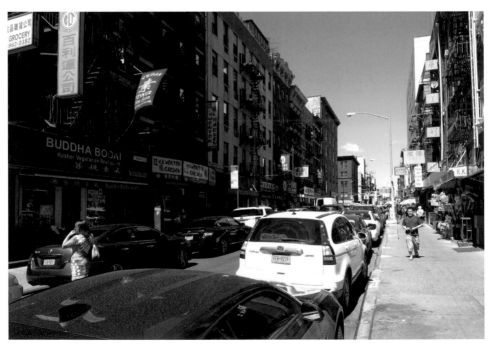

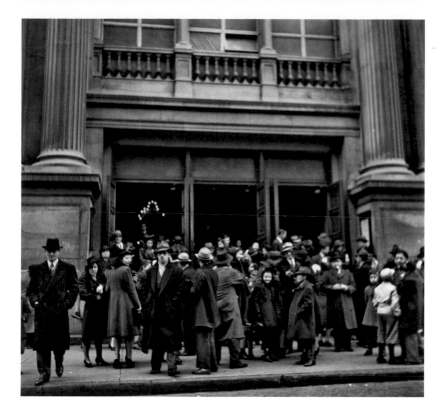

OUR LADY OF POMPEII CHURCH: The history of this Italian-American church begins in the 1890s, with a chapel on Waverly Place. It then relocated to Sullivan Street and later to 214 Bleecker Street, in a former Universalist Church that had been built in 1862. When that building had to be demolished in the 1920s to allow for the extension of Sixth Avenue, the church moved to its current home, a new building at Bleecker and Carmine Streets. The new building was dedicated in 1928. The adjacent Father Demo Square was named after the church's longtime pastor.

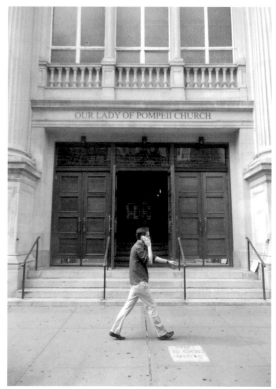

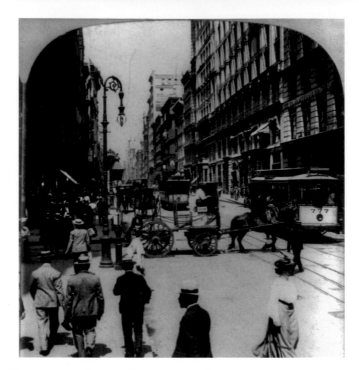

BROADWAY NORTH FROM PRINCE STREET: SoHo (the area South of Houston Street, north of Canal Street, between 6th Avenue and Crosby Street) is a shopper's delight. The neighborhood is also known for its historic architecture. A 26-block section of SoHo was designated by the NYC Landmarks Commission in 1973. The SoHo Cast Iron Historic District contains 500 buildings, a number of which feature cast iron storefronts, which became popular starting in the 1840s and lasted through the 1870s. Its status as a historic district has kept the 19th century flavor of much of SoHo intact.

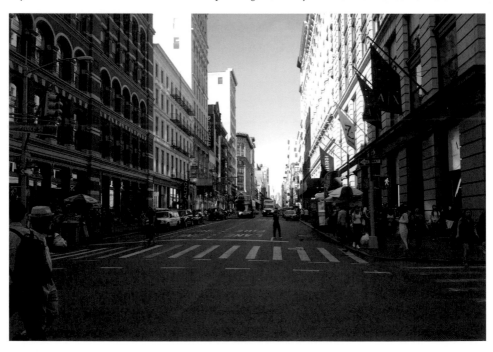

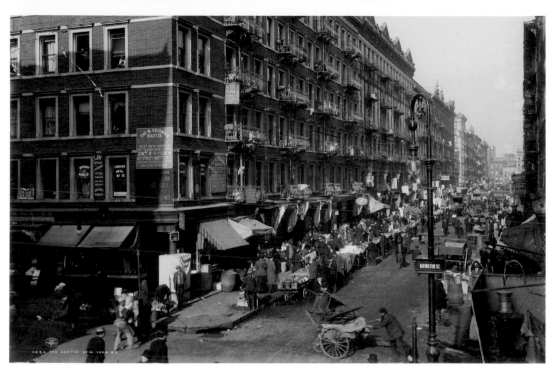

RIVINGTON STREET: Many of Lower Manhattan's most crowded, noisy, busy, and poverty-stricken slums of old are so completely gentrified these days that it is hard to believe they were once crime-filled neighborhoods, teeming with newly arrived immigrants. In 2016, a three-bedroom, one-bathroom apartment on Rivington Street was listed at $6,000 per month.

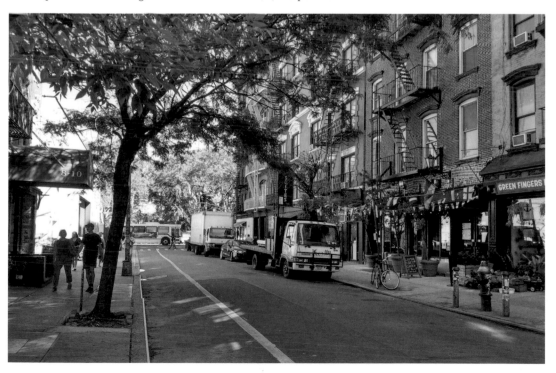

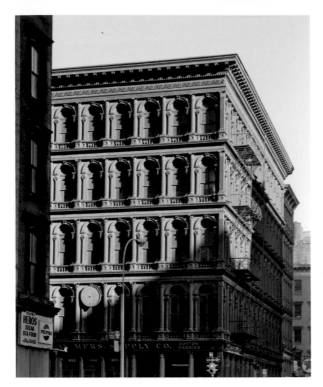

488-490 BROADWAY: Located at the corner of Broome Street and Broadway, the five-story E. V. Haughwout & Company Building was built in 1857 on land that had been owned by John Jacob Astor. This cast iron building was designed by John P. Gaynor for a firm that sold silver, china, and crystal. Its elevator, installed at the time of construction, was one of New York City's earliest. As of 1970, the owner was the Broadway Manufacturers Supply Corporation.

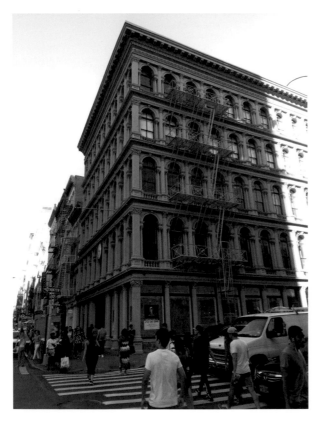

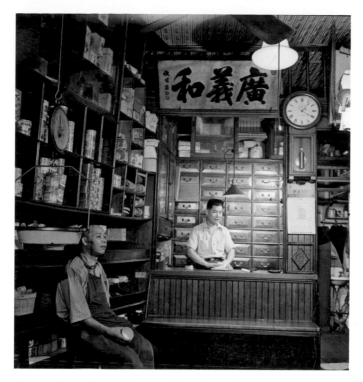

CHINATOWN FOOD SHOPPING: Chinatown has always been known as a place to shop for a wide array of fresh fruit, vegetables, fish, meat, and other groceries and dry goods. There are numerous markets in the neighborhood offering imports that are hard to find elsewhere in the city. Food items can be purchased in stores or from street vendors who set up their carts in various locations around Chinatown.

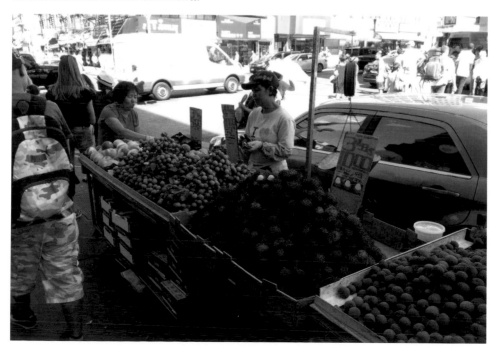

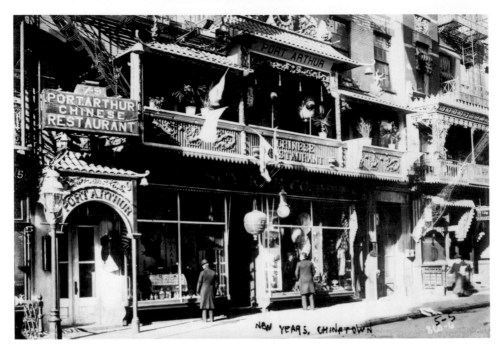

PORT ARTHUR RESTAURANT: Founded in 1897 by a Chinese immigrant named Chu Gam Fai, the Port Arthur Restaurant was a Chinatown landmark for more than eight decades. Located at 7-9 Mott Street, the restaurant was known for its authentic décor and ambiance. The restaurant was on the second and third floors of the building. It closed in the 1970s. Today, the site is occupied by a residential building with a community center on its ground floor. An early 20th century postcard touted it as the "world's best known Chinese Restaurant." Port Arthur was the English name for Lüshun City in China.

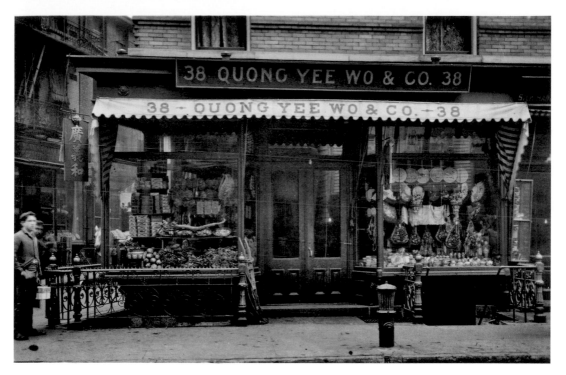

CHINATOWN STOREFRONTS: Since the 19th century, Chinatown has offered a wide variety of shops, selling everything from food to trinkets and knick-knacks. While some stores are geared more toward tourists and non-Chinese New Yorkers, others are aimed at the local Chinese population, and still others cater to a mix of the two. Colorful bi-lingual signs and displays help draw in shoppers.

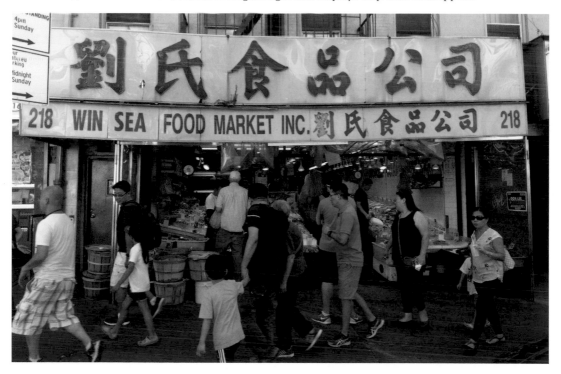

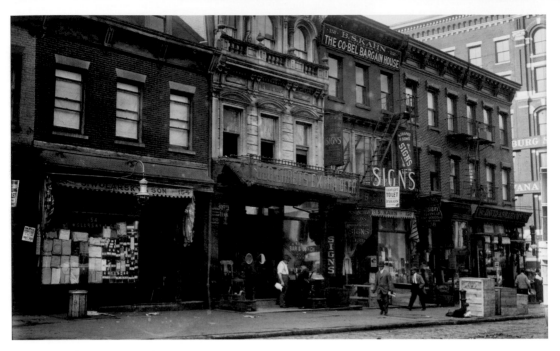

156 CANAL STREET: Ironically, the White House Hotel, near the corner of Elizabeth Street, is where John Schrank lived before attempting to assassinate former president (and then presidential candidate) Theodore Roosevelt on October 14, 1912 during a campaign stop in Milwaukee, Wisconsin. The .38 caliber bullet was famously stopped by the 50-page speech Roosevelt had in his pocket. It did enter his chest but did not reach his heart. Doctors decided it was too dangerous to try to remove it, and so he lived with it for the rest of his life. The three buildings to the right still stand, but the original, ornate #156 has since been replaced.

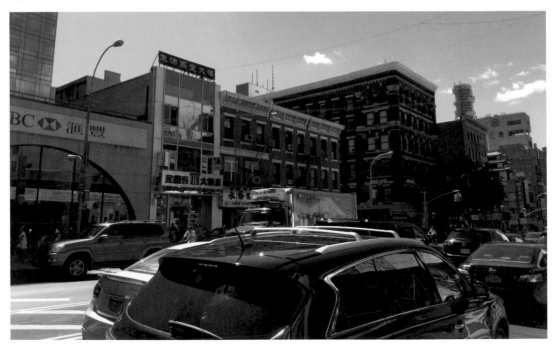

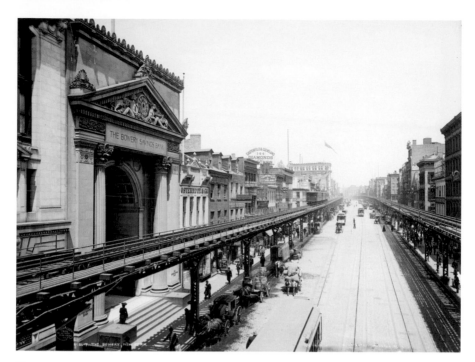

THE BOWERY: The Third Avenue El began operation in 1878, and ran all the way from Lower Manhattan to the Bronx. Elevated train lines' presence in New York City was even more pronounced on a thoroughfare such as this stretch of the Bowery, with only low rise buildings a few stories in height and no skyscrapers. The line was abandoned in the 1950s, one of the last of Manhattan's elevated train lines to be torn down. The Bowery Savings Bank, seen at left in the images, was chartered in 1834. The building dates to 1893 and was designed by Stanford White.

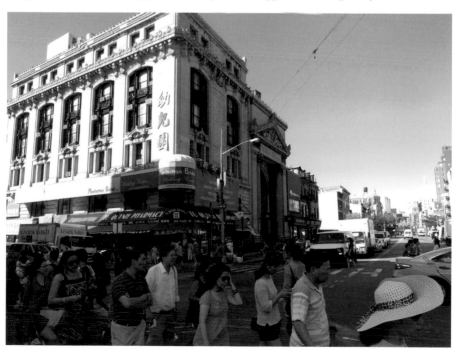

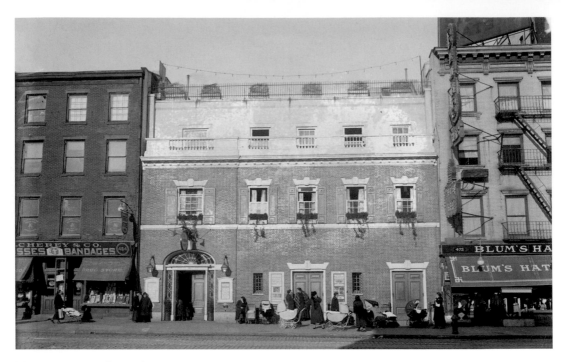

NEIGHBORHOOD PLAYHOUSE: What was originally built as the Neighborhood Playhouse at 466 Grand Street (at Pitt Street) is now the Abrons Arts Center of the Henry Street Settlement. The 300-seat red-brick theater was founded in 1915 by philanthropist sisters Alice and Irene Lewisohn. In its original use, the theater screened movies and put on plays. Many important productions have been done there over the years, including work by Aaron Copland, Agnes De Mille, and Martha Graham. The building was restored in 1996 and 2015.

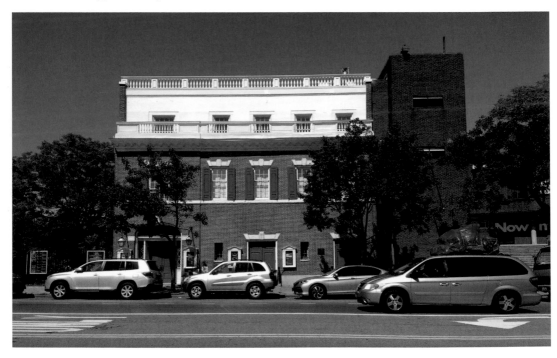

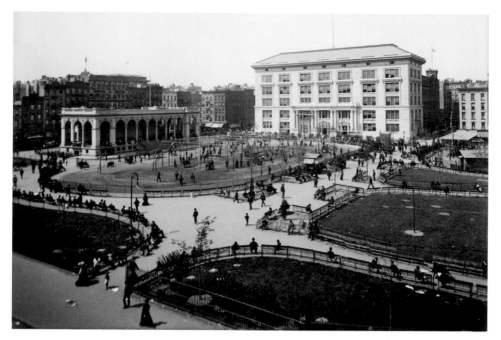

SEWARD PARK: This park, located at the junction of Canal, Essex, and Jefferson Streets and East Broadway, is famous for its groundbreaking playground. When it opened in 1903, the Seward Park playground became the first permanent municipal playground in the country. On opening day, there were 2,000 children running through the park and playing. The highly popular park was considered to be a prototype for future municipal playgrounds. A pavilion with a bathhouse and gym was built in 1904, but demolished in 1936. The park is named for William Seward, who was a governor of New York before becoming the Secretary of State under Abraham Lincoln. It was redesigned by the NYC Parks Department in 2001.

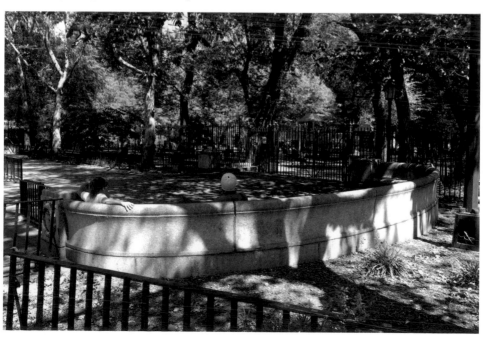

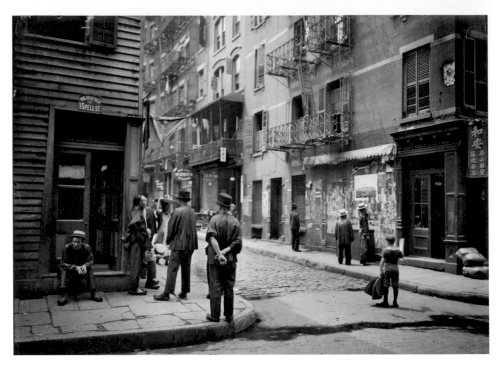

PELL STREET: Nestled in the heart of Chinatown, Pell Street offers a quintessentially authentic experience. But as much as it is known as a mainstay of Chinatown, Pell Street is also famous for a white visitor during the early 20th century. The future songwriter Irving Berlin played piano at a seedy saloon at 12 Pell Street when he was just a teenager. One of the distinct features of Chinatown, like Little Italy, is that most of the buildings are vintage, lending a look of quaint authenticity.

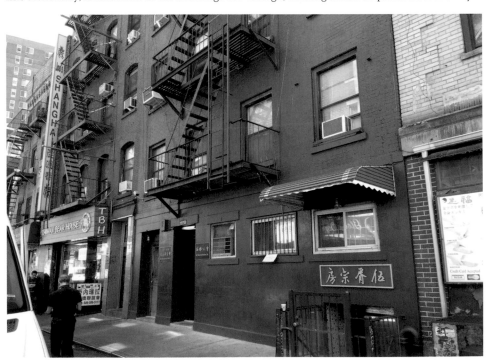

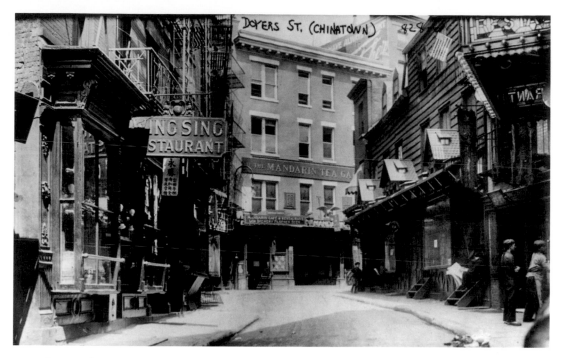

DOYERS STREET: This curvy thoroughfare is in the heart of Chinatown. It was named after 18th century distiller Anthony Doyer, who had a business on "Doyer's" Street. During the late 19th century, it was known as "Murder Alley" and "The Bloody Angle" because of its propensity to attract gang fights. The curves on the city's most crooked street made for good ambushes, and the street was at one point called the most dangerous in America. But Doyers Street was not known only for its crime. Chinatown's first Chinese theater was opened on Doyers Street in 1893.

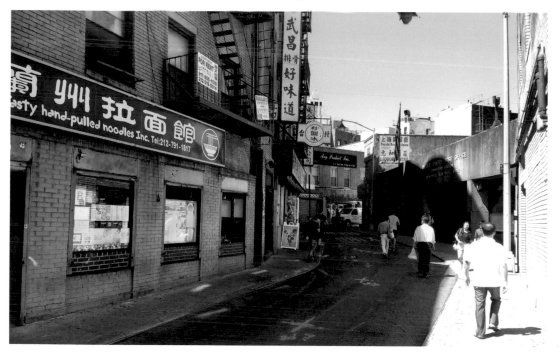

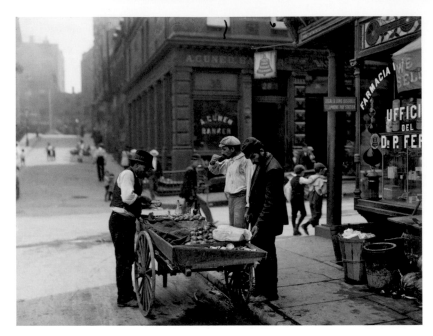

MULBERRY BEND: The section of Mulberry Street between Worth Street and Canal Street runs adjacent to Columbus Park for part of the way. Halfway along the park, it takes a bend to the right. This bend was infamous during the 19th century as the most notorious part of the "Five Points" section of the city, a dangerous and dirty slum with tenements and frequent gang violence. As early as the 1830s, the neighborhood's reputation as a volatile and crowded slum was cemented, and as the years passed its notoriety only grew. Columbus Park, originally called Mulberry Bend Park, was designed by the renowned Calvert Vaux. It opened in 1897. By the early 20th century, this stretch of Mulberry Street had become part of Chinatown.

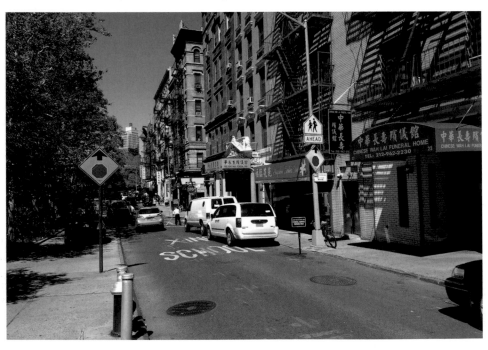

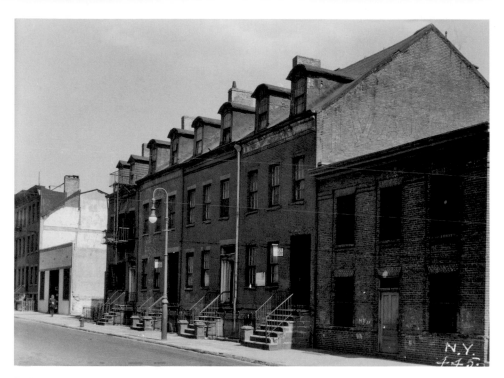

329 CHERRY STREET: In 1753, this property was inherited by Kendrick Rutgers, who used it for farming. A house was built on the property by George Fordham in 1831. As of 1936, when the photo above was taken, the house was owned by a Wilhelmina Blatchford. The site is now occupied by PS 184M, Shuang Wen School, a Chinese-English dual language New York City public elementary school.

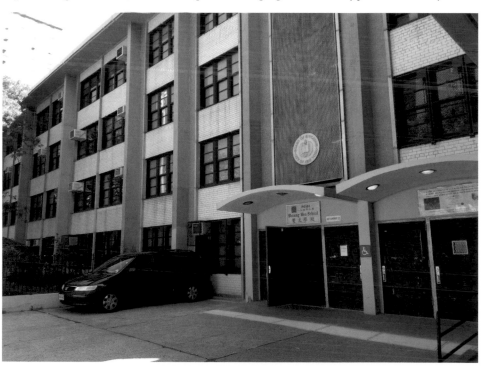

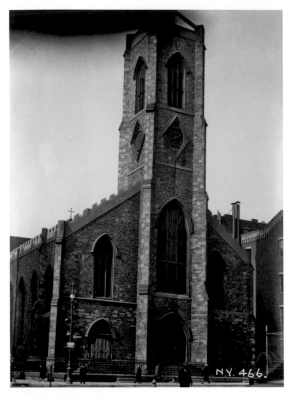

CHURCH OF ST. TERESA: The Gothic church located at 141 Henry Street, at the corner of Rutgers Street, was not the first on the site. The land was originally owned by Henry Rutgers. A Presbyterian church was built in 1798, replaced with the current structure in the 1840s. As Irish Catholic immigrants began to flood the neighborhood, the Rutgers Presbyterian Church congregation moved uptown. The Church of St. Teresa was established in 1863 and took over the existing building. In 1995, the church ceiling collapsed, sending 60,000 pounds of plaster to the floor. A major restoration was completed in 2002. What used to be a poor area has become a popular spot to live, resulting in high real estate prices.

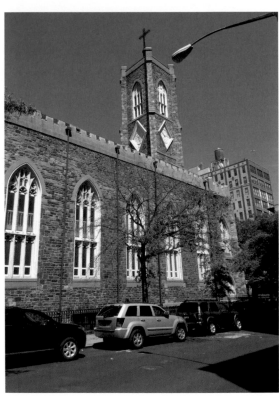

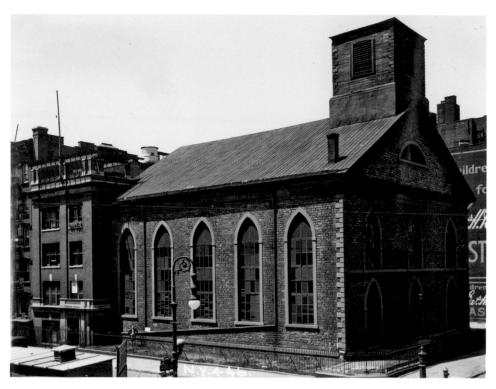

SEA AND LAND CHURCH: Located at the corner of Henry and Market Streets, this elegant stone building was originally built as the Northeast Reformed Dutch Church back in 1819, when the Lower East Side was still semi-rural. In 1866, it was transferred to the Presbyterian Church and became known as the Sea and Land Church, as it was near the East River and catered to sailors. It is now the first Chinese Presbyterian Church.

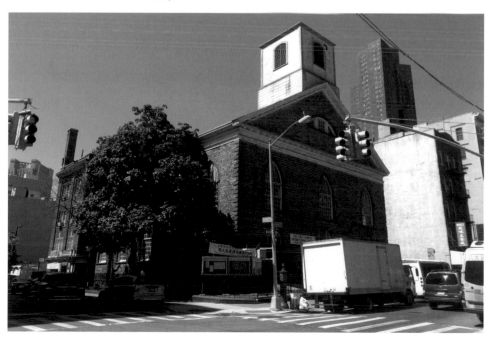

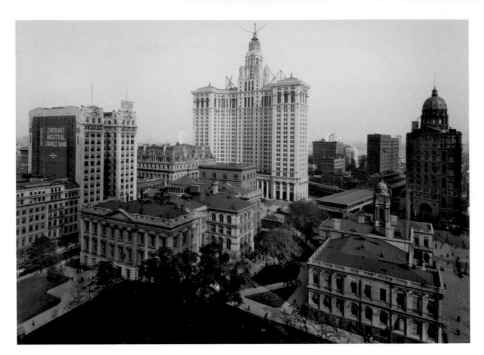

MUNICIPAL BUILDING: The Municipal Building is a New York City government building at 1 Centre Street, opposite City Hall Park and just north of the Manhattan entrance to the Brooklyn Bridge. Rising 40 stories (580 feet), the impressive 600,000 sq. ft. limestone building was completed in 1915 after several years of construction. Designed by McKim, Mead and White, the classically-styled structure is one of the most impressive city government buildings ever constructed in the United States and at the time of its construction was the largest building of its kind in the world. Atop the building is perched a 30-foot-high statue of Miss Civic Pride, designed by Adolph Weinman. The total cost of the 580-foot-high building was $13 million. The monumental building was rehabilitated in 1992.

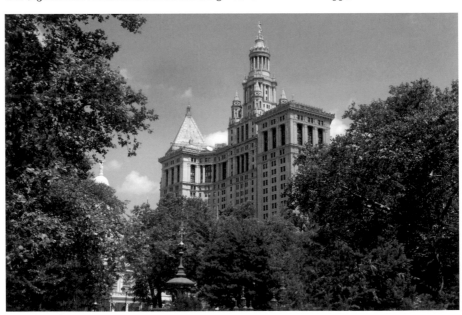

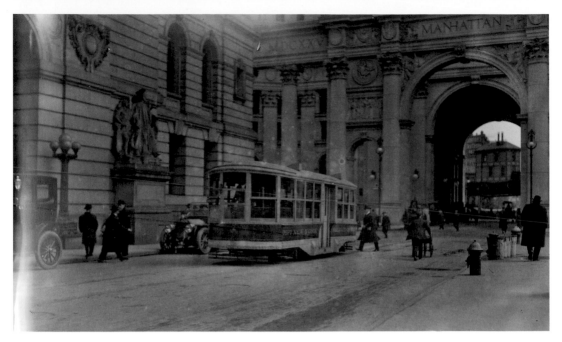

MUNICIPAL BUILDING ARCH: Vehicular traffic used to be allowed through the great arch in the plaza in front of the Municipal Building. The arch was inspired by the arch of Constantine in Rome, which was built in the year 315. Today, the arch and the barrel-vaulted passageway under the Municipal Building are open to pedestrian traffic only. Above the arch and columns, inscribed in Roman numerals, is the date of the founding of New Amsterdam, 1626.

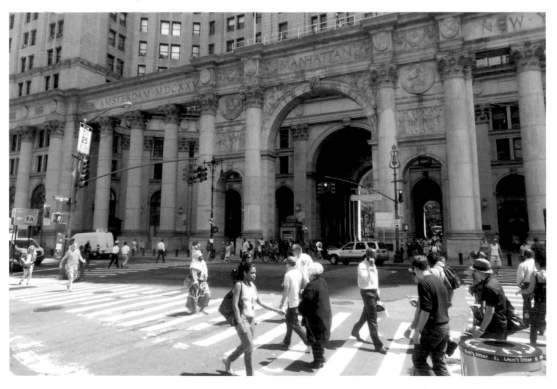

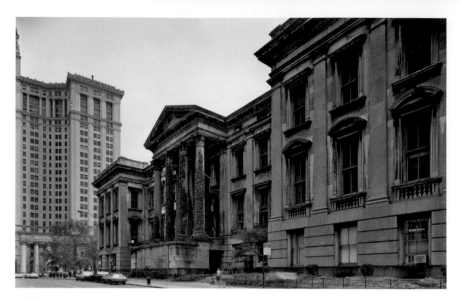

52 CHAMBERS STREET: This courthouse building is a beautiful 19th century architectural masterpiece, but also the legacy of one of the most corrupt politicians in the city's history. It was nearly completed by the mid-1860s, with more than $4 million already spent, when William "Boss" Tweed came into power and felt that the building needed extensive "repairs." The original plasterwork in the building cost $531,594. The Tweed Ring submitted bills for $1,294,684 for "repairs to plasterwork." The original carpentry cost $1,439,619; "repairing" it before the building was finished cost another $750,071. Incredibly, the cost of the building increased by more than $8 million dollars; $41,190 was "spent" just on brooms! Tweed accomplished this massive corruption with the help of unscrupulous contractors who marked up prices and submitted phony bills. Tweed was arrested in 1871, and the building was finally completed in 1881, three years after Tweed's death.

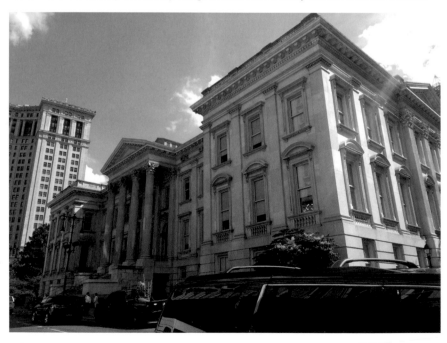

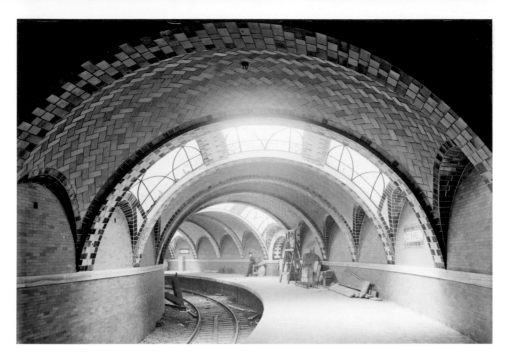

CITY HALL SUBWAY STATIONS: The old City Hall station, the first in the subway system, was built in 1904 and designed by Rafael Gustavino (known for his vaulted arches). Despite its beauty, the station was never very popular, and it was discontinued as a station in 1945, though No. 6 trains still use it as a turning loop. This architectural treasure is preserved but is closed to the public, except for occasional tours. The design of the Municipal Building entrance to the Brooklyn Bridge/ City Hall station on the BMT line, completed in 1914, is reminiscent of the City Hall Station and is where the famous "That's not a knife" scene in Crocodile Dundee was filmed.

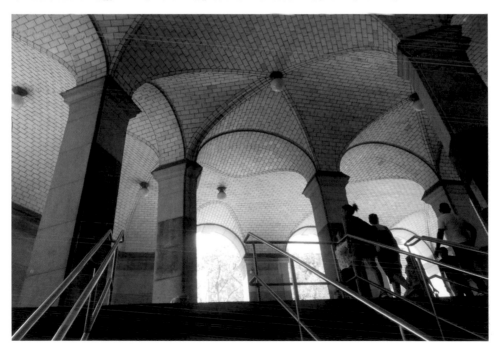

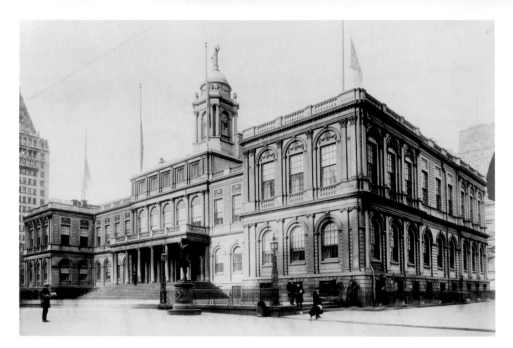

CITY HALL: When construction began in 1803, the new City Hall building was on the very northern edge of town. Elegant Massachusetts marble was used for the south-facing front and the sides, but the back (the north-facing side) was red sandstone, because it was thought nothing important would be built north of that point. City Hall was built on the site of New York's first almshouse (1736-1797). Though it was on the outskirts of town when built, by the late 19th century, it was in the heart of the city. Two of the city's earliest skyscrapers (and the tallest in the world at the time) would be built along Park Row just south of City Hall—The New York World Building (1890) and the Park Row Building (1899).

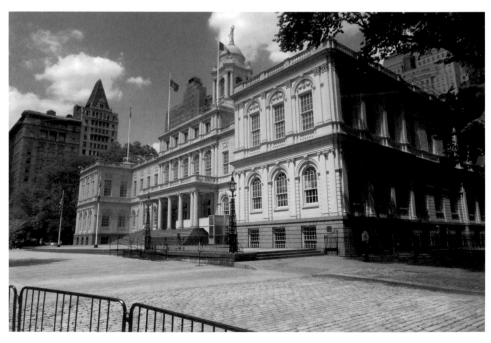

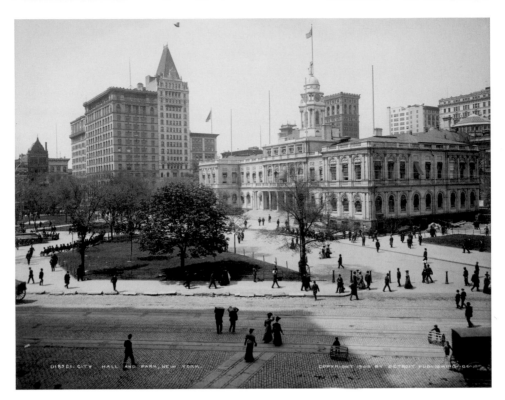

CITY HALL PARK: The park is located on the site of a common that had been in use since the Dutch days. The site has had many uses over the years. It was the location of the city jail from 1775-1838 and also the location of British soldiers' barracks in the 18th century. The park's name reflects its current occupant, New York's City Hall.

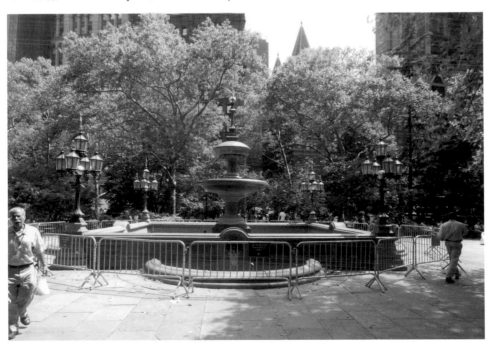

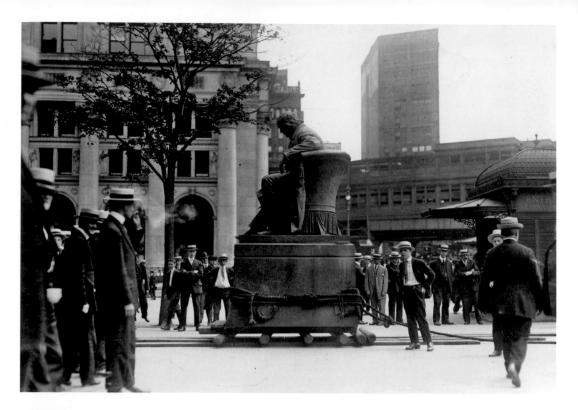

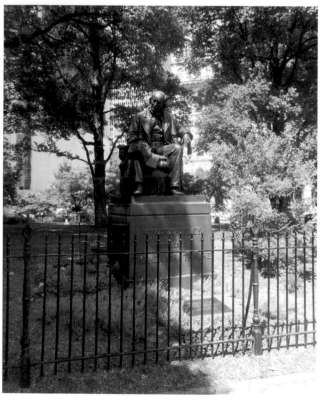

HORACE GREELEY STATUE:
The statue that currently graces the northeast part of City Hall Park was originally cast in 1890 and its first home was in front of the Tribune Building along Park Row (Horace Greeley was one of the founders of the newspaper). It was moved to City Hall Park in 1916, as is captured in the image seen here. The sculptor was John Quincy Adams Ward.

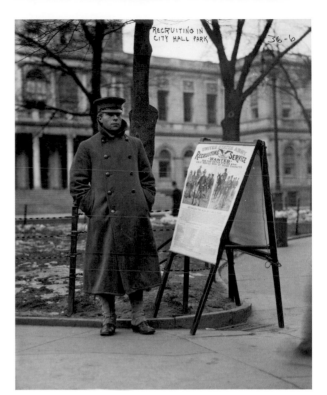

CITY HALL PARK MESSAGES:
The city's parks have long been a place for the sharing of different political views, opinions, and causes. An army recruiter stands in the park in 1908, hoping to drum up some interest in joining the armed forces. Present day, signs, chalk drawings, and literature can be found to express views on a number of hot-button issues.

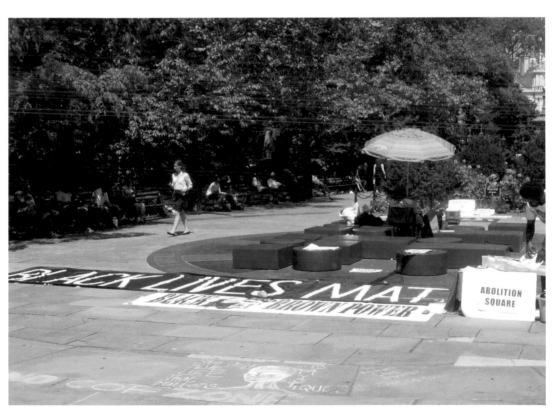

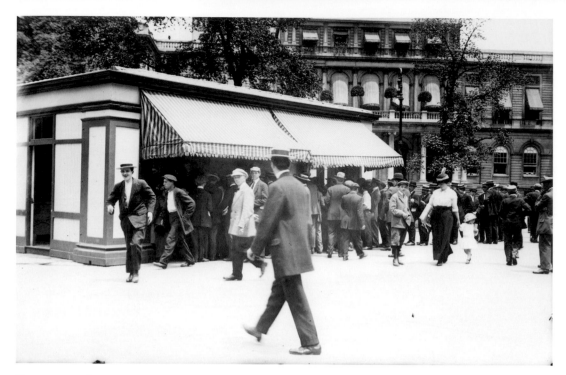

VENDORS AT CITY HALL PARK: Back in the early days of the 20th century, Nathan Straus sold glasses of milk in City Hall Park for a penny each. These days, farmers' market vendors set up along the Broadway side of the park and peddle their wares, including produce and baked goods. The area gets a lot of lunchtime and evening foot traffic due to the many government buildings and office buildings in the vicinity.

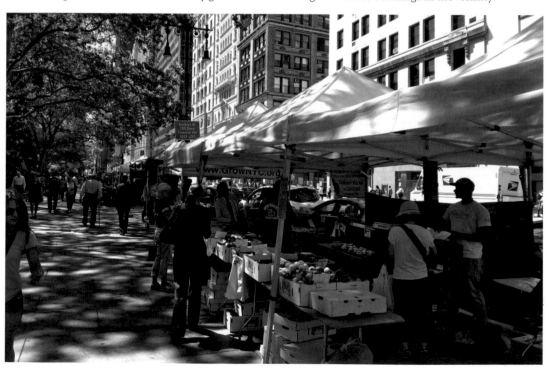

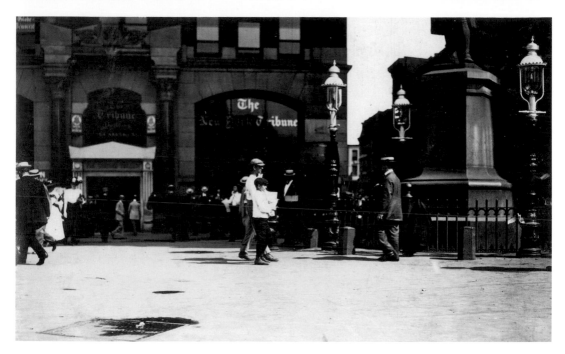

SELLING NEWSPAPERS ON PARK ROW: Before television and radio, newspapers were the quickest way to learn about the latest developments. In the early 20th century, young children stationed at various high-traffic locations around the city sold newspapers to passersby. If late breaking news was received and special "extra" editions were printed, the kids (aka newsies) could yell that now-clichéd slogan: "Extra! Extra! Read all about it!" The age of newsies was recalled in the popular Broadway musical that ran from 2012-2014 on West 41st Street. These days, newspapers are still sold by street vendors (adults), but also in stores like this one along Park Row.

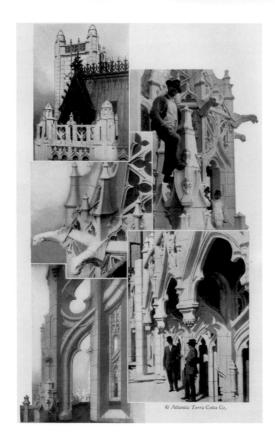

© Atlantic Terra Cotta Co.

WOOLWORTH BUILDING DETAILS:
Located at 233 Broadway, the Woolworth Building occupies a plot 152 x 197 feet at Broadway and Barclay Streets. Completed in 1913, the Woolworth Building was the world's tallest building for 17 years. The Gothic masterpiece cost $13.5 million to construct and is known for its ornate terra-cotta details. The gothic stylings of the stonework make this building one of the most heavily and beautifully ornamented skyscrapers in the city.

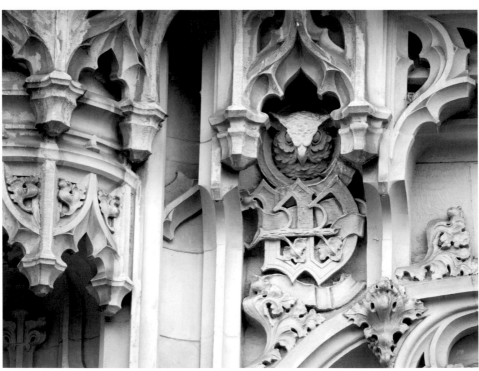

OLD POST OFFICE: In 1870, a new post office building was built at the southern tip of City Hall Park. This massive four-story granite French Second Empire-style building replaced much of the park. Though technologically modern when constructed, the $8.5 million building became obsolete within a few decades. Though critics now praise the structure, in its time, it was derided as a monstrosity that destroyed a beloved park. There were calls for it to be demolished for years before it actually was knocked down in 1939, after which the park was restored to its former glory.

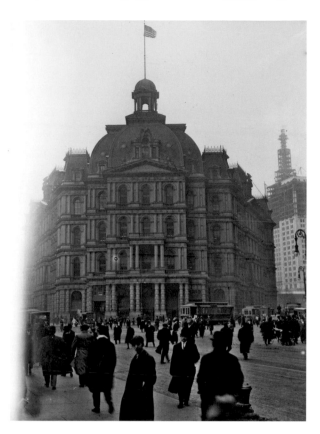

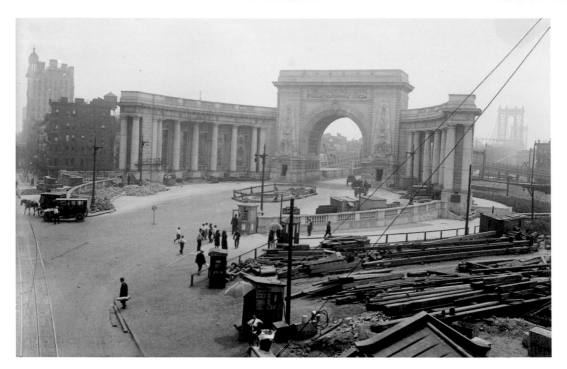

MANHATTAN BRIDGE ARCH: The bridge itself, which connects Brooklyn and Manhattan, was completed in 1909, but the grand arch and colonnade on the Manhattan-side entrance (at Canal, Forsyth, and Bayard Streets) was completed in 1915. It was designed by Carrere and Hastings, who looked to the Porte Saint Denis in Paris as an inspiration for the arch and Bernini's masterpiece at St. Peter's Square in Rome for the colonnade.

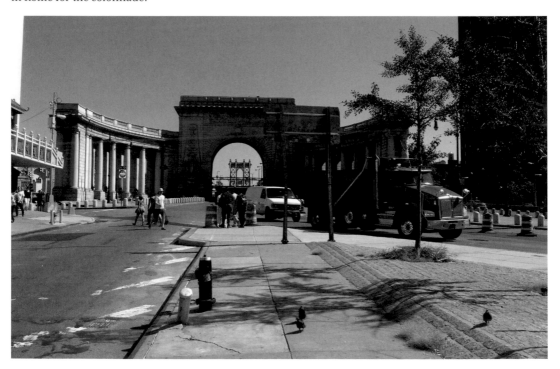

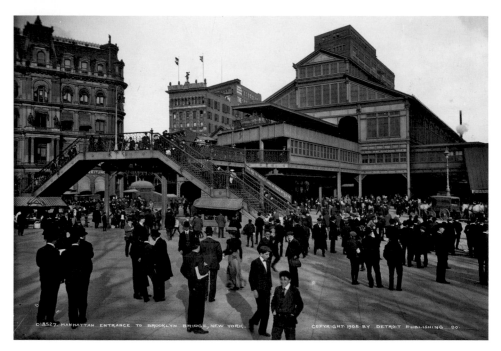

MANHATTAN ENTRANCE TO THE BROOKLYN BRIDGE: The word bridge brings to mind automobiles, but in the past, most bridges were for pedestrians as much as vehicles. The Brooklyn Bridge is a good example of this. The first bridge between Brooklyn and Manhattan, it was wildly popular as a foot crossing from the moment it opened. In fact, the first day it opened in 1883, 250,000 people crossed the bridge. Even today, the bridge remains a popular pedestrian crossing. The entrance plaza structure on the Manhattan side has since been demolished, leaving a more aesthetically pleasing vantage point.

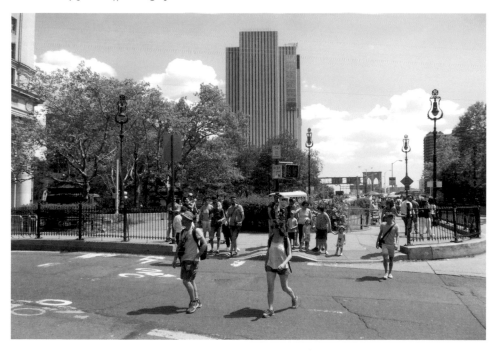

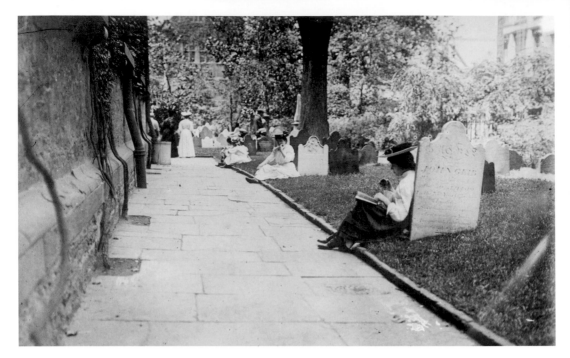

ST. PAUL'S CHAPEL CHURCHYARD: When built in 1766, the Episcopal St. Paul's Chapel was a northern outpost of Trinity Church. The adjoining cemetery has long been a place for quiet reflection, offering a rest to the weary and a break from the demands of the day. The church, located on Church Street between Fulton and Vesey Streets, was used as a command center following the September 11, 2001 attacks on the nearby Twin Towers. As a result of the buildings' collapse, the graves in the churchyard were covered in debris and soot and had to be vacuumed and washed. The cemetery reopened to the public in 2003.

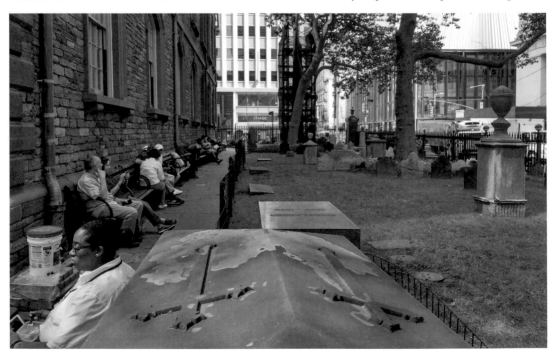

TWIN TOWERS/FREEDOM TOWER:
The tragedy of September 11, 2001,
caused the destruction of one of New
York City's most iconic and dominant
landmarks—the Twin Towers, aka
the World Trade Center. The towers
had been built starting in the late
1960s and were completed in 1973.
The new One World Trade Center,
aka the Freedom Tower, opened in
2014. At 104 floors and 1,776 feet high
(compared to the 1,368 of the original
One World Trade Center), it is the
tallest building in the United States
and it easily dominates the skyline of
lower Manhattan.

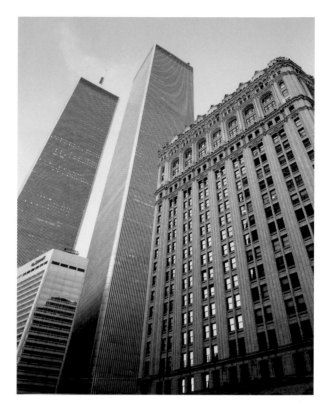

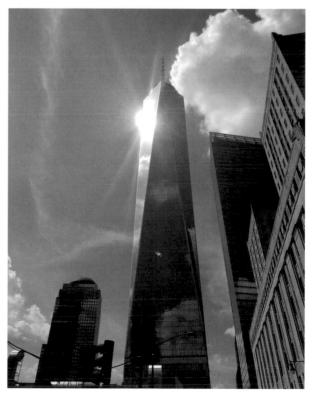

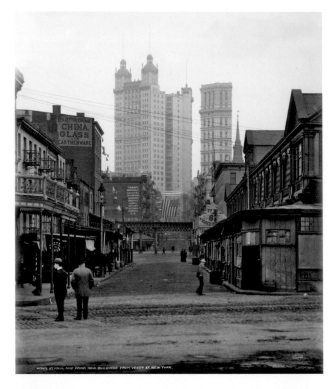

VESEY STREET: The street was named after the first rector of Trinity Church, William Vesey. The street in the early 20th century was quite different from its appearance today. Back then, the sight line to Park Row was clear. The street's proximity to first the World Trade Center and then the Freedom Tower gained it national attention.

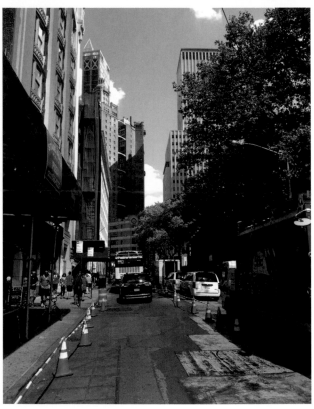

ST. PETER'S CHURCH: When St. Peter's was founded on Barclay Street in lower Manhattan, there were only 400 Catholics in New York City. The cornerstone was laid on October 5, 1785, by the Spanish ambassador, Don Diego de Gardoqui. The first mass was said in the new church on November 4, 1786. St. Peter's was the first Catholic parish in all of New York State. The current, larger Greek Revival structure was completed in 1840 at a cost of $110,000. At one point during the 1860s, there were 20,000 Catholics within the parish limits. The parents of the infamous bandit, Billy the Kid, were married at St. Peter's, and he was supposedly baptized there.

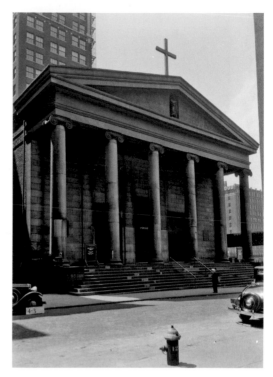

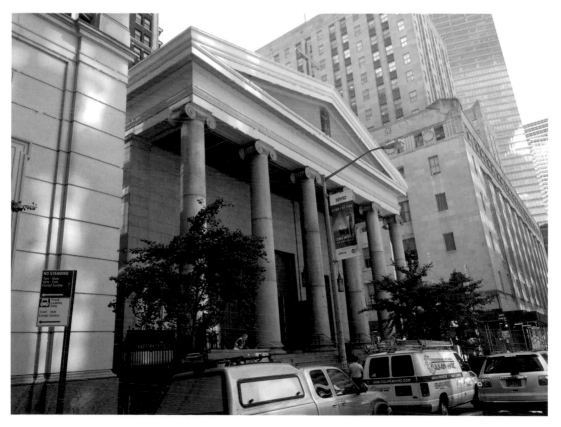

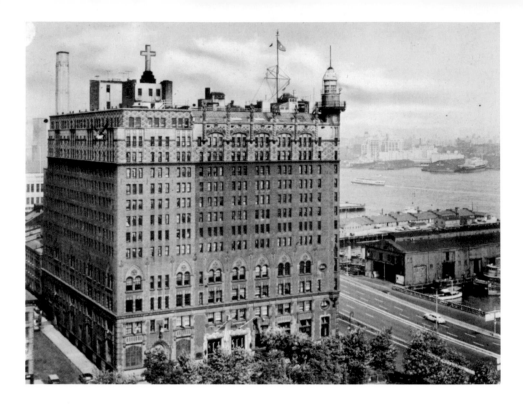

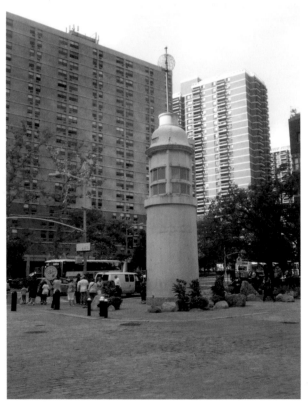

SEAMEN'S CHURCH INSTITUTE LIGHTHOUSE TOWER: In 1913, a special memorial service was held at the Seamen's Church Institute (located on South Street) for the victims of the *Titanic* disaster. In honor of the *Titanic*, Reverend David Greer, Bishop of New York, gave a sermon dedicating a lighthouse tower for the roof of the building: "As its light by night shall guide pilgrims and seafaring men from every clime into this port, so may they follow Him who is the Light of Life across the waves of this troublesome world to everlasting life ... " The lighthouse had a green light that was visible for twelve miles. The lighthouse tower is visible on the right corner of the roof in the image at top. The tower was removed and given to the South Street Seaport Museum in 1976. It is located at Pearl and Fulton Streets.

SOUTH STREET SEAPORT MUSEUM: Efforts to create the Seaport began in 1966, when the idea of preserving a largely intact neighborhood highlighting Lower Manhattan's seafaring heritage was first floated. The museum, which opened in 1967 and is located at 12 Fulton Street, was named by Congress in 1998 as one of America's National Maritime Museums. It was damaged by floodwater during Hurricane Sandy in 2012, and though it reopened by December 2012, it did not have any new exhibitions until 2016. Next door is Bowne & Co. Stationers, a business that began in 1775, and which opened this shop at 211 Water Street in South Street Seaport in 1975, highlighting old fashioned methods of letterpress printing.

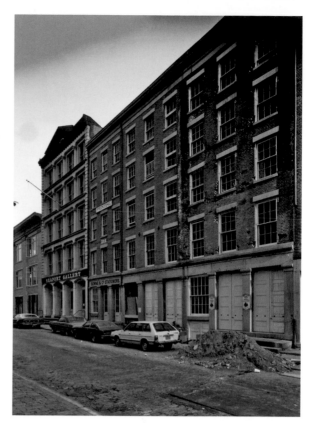

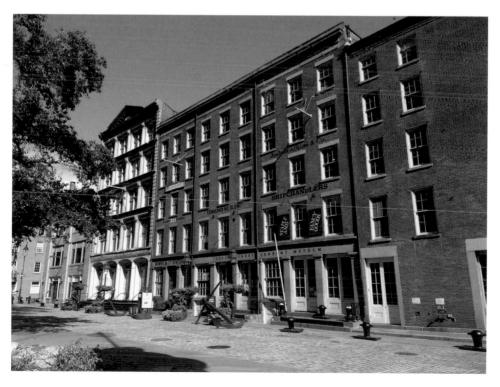

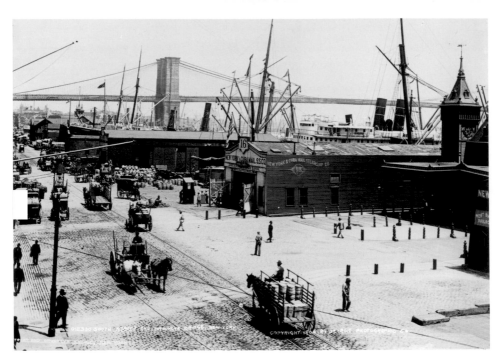

PIERS 16 AND 17: One of the biggest draws of the Seaport has been the shopping at the red Pier 17 Mall, which opened in 1985 with a focus on quirky homespun shops and souvenir stands. This waterfront shopping experience, with views of the Brooklyn Bridge, helped make the Seaport the #1 attraction in the city in 1988. That popularity was relatively short lived, and the Pier 17 Mall was demolished in 2014. A new one was constructed in its place to attract larger retailers. The new Pier 17 was designed to feature more outdoor space, including a rooftop garden.

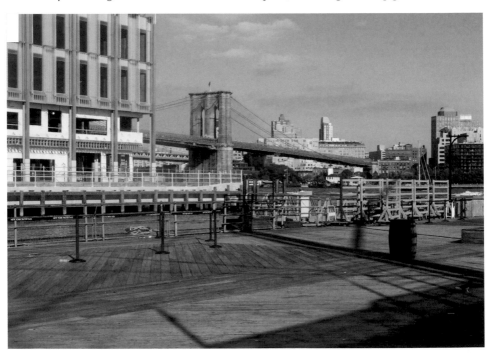

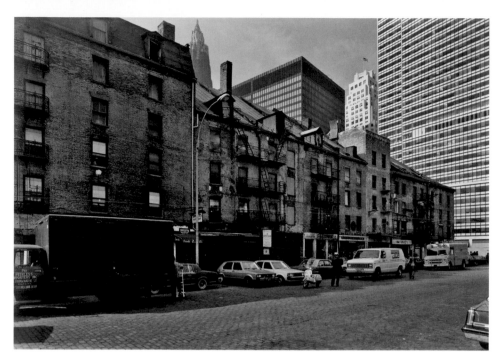

SCHERMERHORN ROW: This block of buildings is the centerpiece of South Street Seaport. Built by a merchant named Peter Schermerhorn between 1810 and 1812, the buildings were home to stores, counting houses, boarding houses, and hotels over the years. The buildings received landmark status in 1968, but restoration was not done until 1983. Special bricks, 262,000 of them, were made to order to match the originals, which were smaller than ordinary bricks. As part of the restoration, sagging building facades were stabilized and 140,000 sq. ft. of slate was used for reroofing.

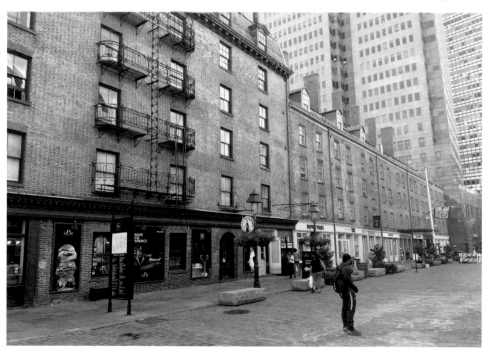

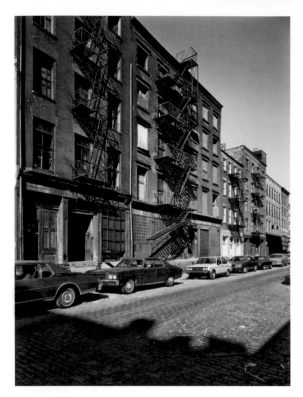

224-236 FRONT STREET: Though the South Street Seaport Museum opened in the 1960s, much of the area was still in unrestored condition during the 1970s and early 1980s. This section of Front Street, for example, now features retail and dining. Yet even today there are still buildings in the Seaport area in need of major restoration or undergoing renovation.

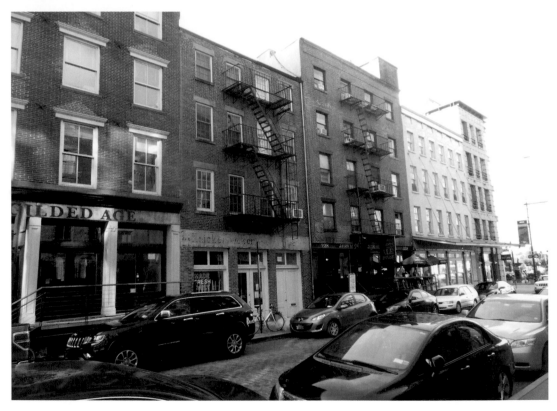

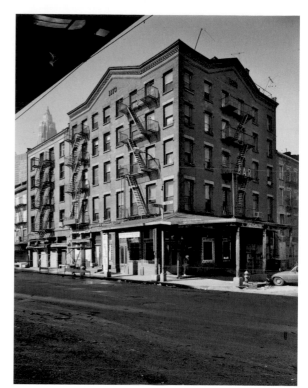

HARRIET ONDERDONK BUILDING:
The five-story building at 116-119 South
Street, at a key location on the corner
of Peck Slip, was built in 1873 as stores,
offices, and lofts. In 1903, a new owner
converted the upper floors to lodgings,
creating 43 hotel rooms. As of 1976,
the rooms were inhabited by retired
fishmongers. As of 2016, the ground floor
featured a restaurant, just as it had when
first built in the 19th century.

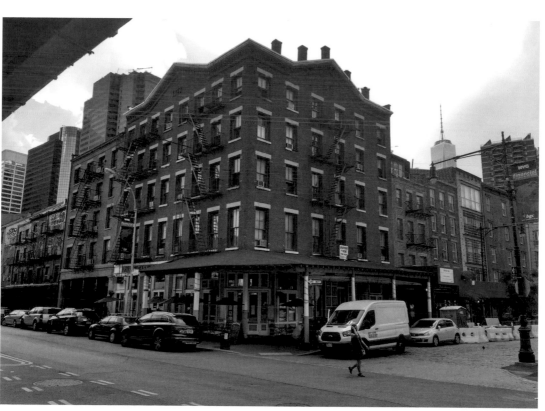

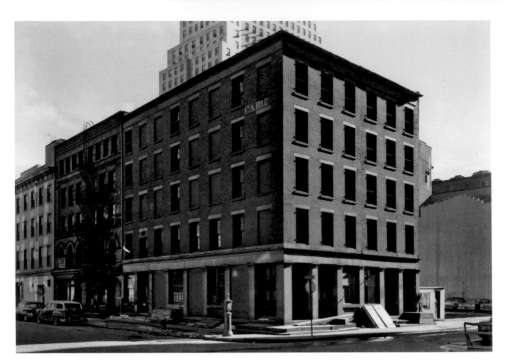

THE CARLE BUILDING: Located at the corner of Maiden Lane and Water Street, this early Greek Revival style commercial building (known as 151-153 Water Street and 134-136 Maiden Lane) was constructed around 1839. It was built by Silas Carle, after whom the hamlet of Carle Place, Long Island is named. The Carle family were druggists and paint dealers. The building was demolished in 1960. The building that stands in its place now, Wall Street Plaza, aka 88 Pine Street, was designed by James Ingo Freed of the firm I. M. Pei & Associates, and built between 1970 and 1973.

JOHN STREET METHODIST CHURCH:
The current building at 44 John Street is
the third church of this name. Founded in
1766, the John Street Church is the oldest
Methodist congregation in the United
States. Designed in the Greek Revival style,
the current building was dedicated in 1841
by Bishop Elijah Hedding and replaced the
second version due to the widening of John
Street. The congregation was founded by
Philip Embury, who had been converted
to the faith by the Methodist founder John
Wesley. Today, the church sits quietly,
nestled among neighboring skyscrapers.

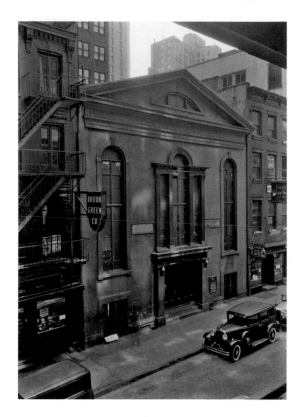

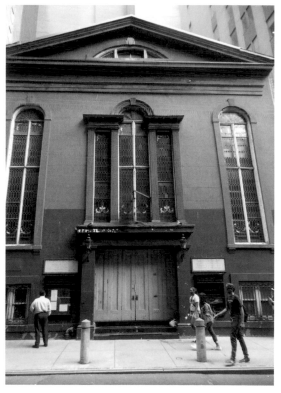

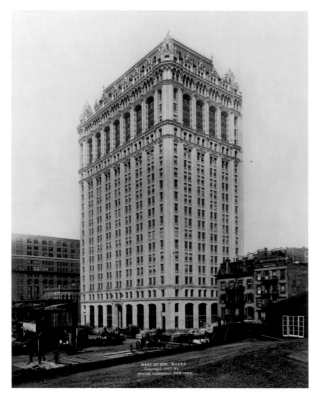

THE WEST STREET BUILDING:
The 23-story neo-Gothic building at 90 West Street was designed by Cass Gilbert and completed in 1907. Gilbert's next skyscraper would be the Woolworth Building. The exterior of 90 West Street is made of granite and terra cotta, with polychrome accents. 90 West, located just south of the Twin Towers, was seriously damaged as a result of the attacks on September 11, 2001. Originally designed as an office building, it was renovated and then converted to high end apartments with views of the Hudson River and Freedom Tower.

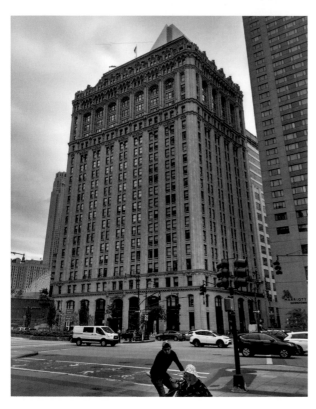

WALL STREET TOWARD TRINITY CHURCH:
The Gillender Building, designed by Berg
and Clark, was completed in 1897. At 273
feet high, the 20-story structure was among
the tallest buildings in New York City when
built. The foundation material consisted of
fine loose wet sand, so pneumatic caissons
had to be used, covering about three-fifths
of the area of the site. Shown here in 1897,
the narrow building was demolished in
1910 and replaced with the much taller
Bankers Trust Tower (the building with the
pyramidal top in the present-day image).
According to a 1910 New York Times article,
it was the first time a "high class office
building" was torn down to make way for a
more elaborate structure.

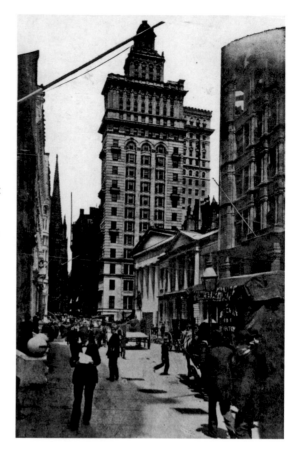

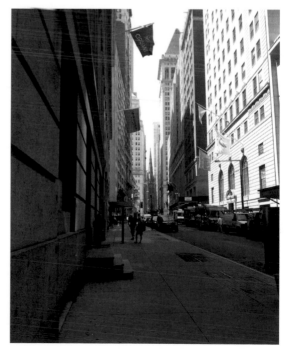

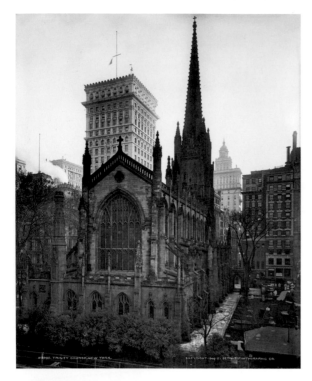

TRINITY CHURCH: Designed by Richard Upjohn and completed in 1846, the present Trinity Church is the third iteration on the site. The first Trinity was built in 1698 and destroyed by fire in 1776, and the second built in 1790 and damaged by heavy snowfall in 1838. Trinity is one of the city's best known churches and a tourist attraction for anyone visiting Lower Manhattan. For decades after it was built, the spire of Trinity Church was the highest structure in the city, but by the 20th century, the church, located on Broadway at Wall Street, was beginning to become dwarfed by its surroundings.

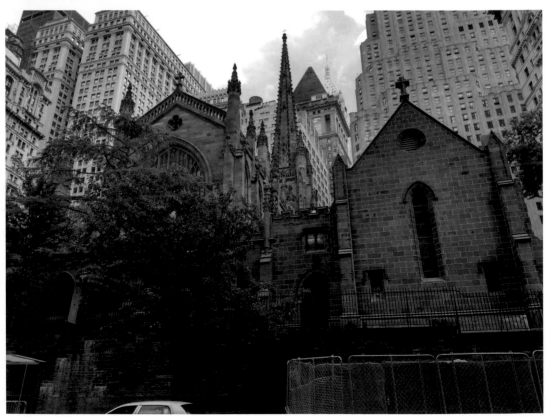

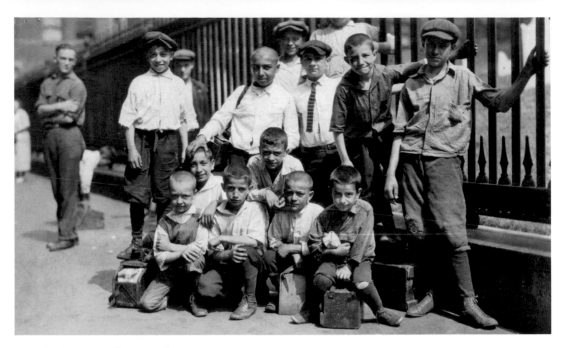

IN FRONT OF TRINITY CHURCH: Bootblacks used to be a common sight on the city streets, and many of them were young children. In the 1924 photograph at top, a group of them pose in front of Trinity Church. Although there are still shoeshine stands in the vicinity and indeed all around the city, the most notable presence in front of the church today is a food vendor.

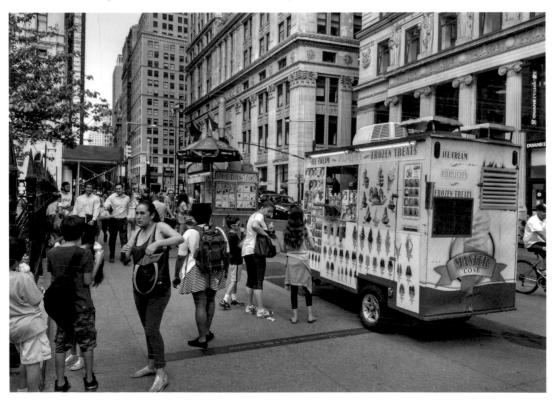

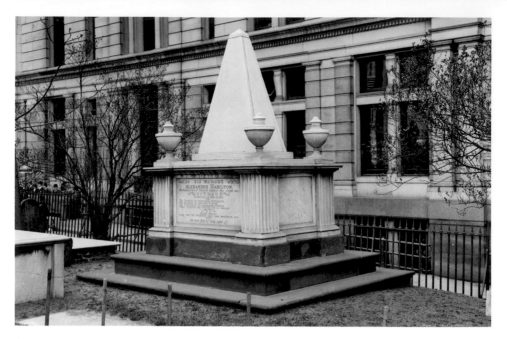

ALEXANDER HAMILTON'S GRAVE: Founding father Hamilton is the most famous burial in the Trinity Church Cemetery, which is the final resting place of numerous early American politicians and war heroes. The dedication on the handsome Hamilton monument reads: "The Corporation of Trinity Church has erected this monument in testimony of their respect for the PATRIOT of incorruptible INTEGRITY, the SOLDIER of approved VALOUR, the STATESMAN of consummate WISDOM; whose TALENTS and VIRTUES will be admired by Grateful Posterity long after this MARBLE shall have mouldered into DUST." The popularity of the hit Broadway musical Hamilton has resulted in numerous visitors to Alexander Hamilton's monument. His wife Elizabeth is also buried at the Trinity Cemetery.

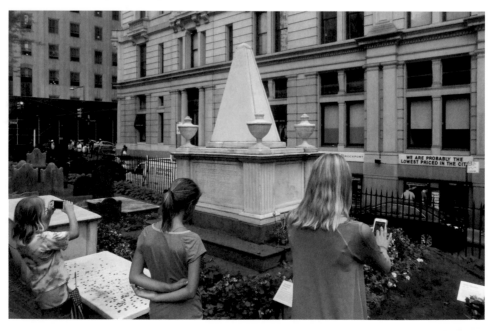

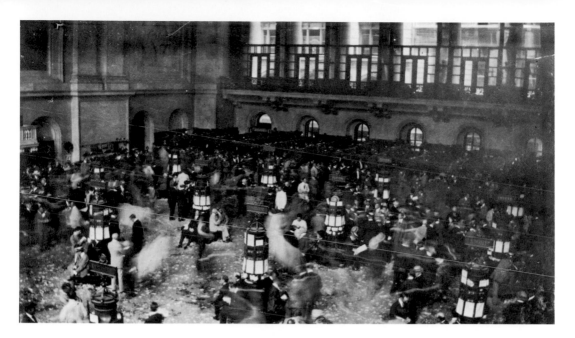

THE NEW YORK STOCK EXCHANGE: Located on Broad Street, the NYSE had its origins in 1792 when 24 merchants and stockbrokers met under a buttonwood tree outside of 68 Wall Street. In 1817, the group adopted a constitution and called themselves the New York Stock & Exchange Board. It moved into the first building of its own in 1865, at 10-12 Broad Street. The current Greek Revival building dates to 1903. The frenzied stock exchange trading floor has been in the public imagination for decades, thanks in part to its depiction in films.

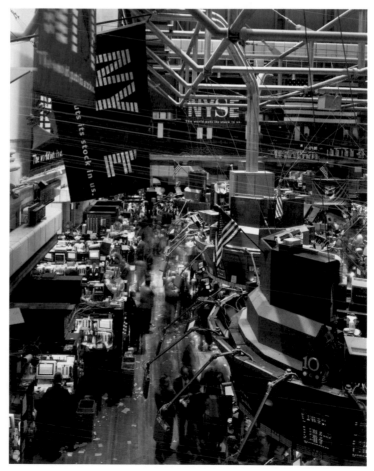

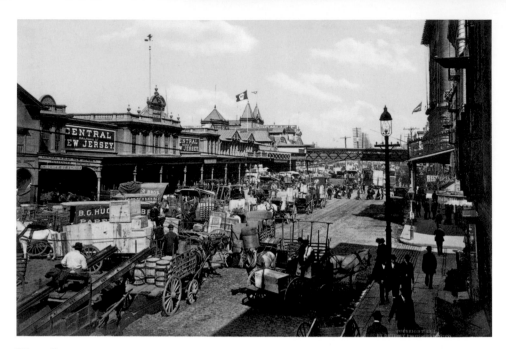

WEST STREET: While some Lower Manhattan streets look very much the same as they did 50 or 100 years ago, West Street has changed a great deal. What is also known as New York State Route 9A becomes 11th Avenue north of Gansevoort Street, and then 12th Avenue north of 22nd Street. West Street runs along the Hudson River and passes the Freedom Tower and the former site of the Twin Towers before ending at the Battery Park Underpass just north of Battery Park. At the time of the September 11 attacks, West Street was undergoing a major reconstruction. The new West Street is supposed to be a pedestrian friendly boulevard. In 2006, the first phase of improvements and reconstruction from damage sustained during the attacks, was opened.

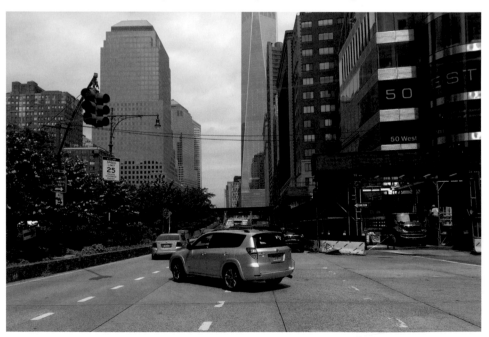

NORTH ON BROADWAY FROM BOWLING GREEN: This view has not changed all that much in the last 100 years, as compared to others in downtown Manhattan. Perhaps the most noticeable new addition is the sculpture of a charging bull at the north end of Bowling Green. This sculpture was a surprise Christmas gift to the New York Stock Exchange, in front of which it was placed one night in December 1989. The NYSE promptly had it removed. Through the help of a member of the Bowling Green Association, the sculptor, Arturo Di Modica, was allowed to have the 3.5-ton bull moved to its current spot. Tourists can be seen at all hours posing for pictures and rubbing the bull for good luck.

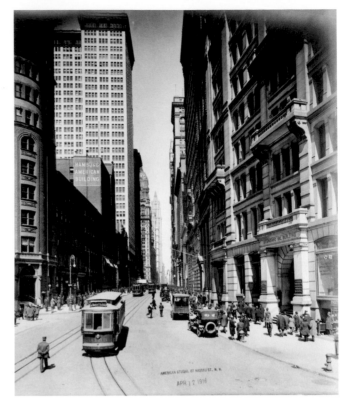

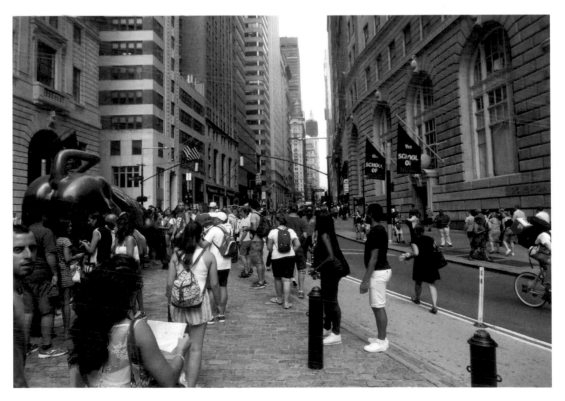

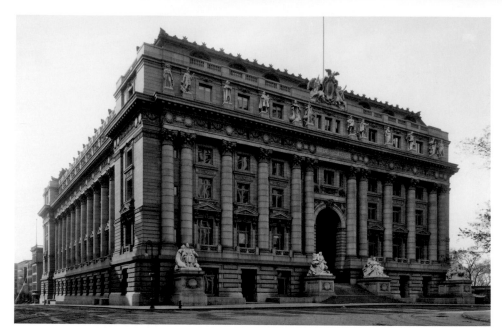

CUSTOM HOUSE BUILDING: One of the most impressive architectural treasures in the city is just north of South Ferry, on the southern edge of Bowling Green. The massive 450,000 sq. ft. Alexander Hamilton United States Custom House was designed by Cass Gilbert (who would go on to design the Woolworth Building) and built between 1900 and 1907. The four sculptures on the building's pedestals were designed by Daniel Chester French. In 1994, the building was converted to house the Gustav Heye Center of the National Museum of the American Indian, which was originally the privately-owned Museum of the American Indian (located on 155th Street) before the collection was transferred to the Smithsonian Institution and thus became eligible to occupy the federal building at Bowling Green.

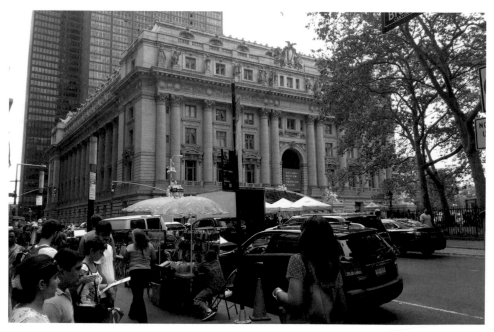

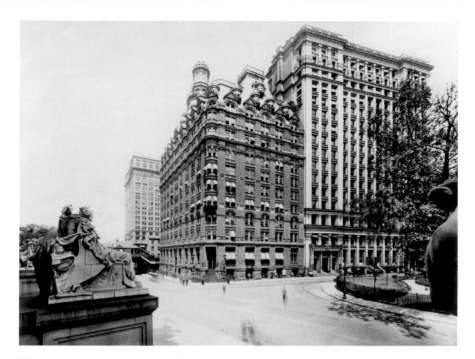

WASHINGTON AND BOWLING GREEN BUILDINGS: The area around Bowling Green (one of the city's oldest public spaces), near the southernmost tip of Manhattan Island, has been a center for commerce since the 1600s. The building at right is the 350-foot-high Bowling Green Building, designed by the Audsley Brothers, and completed in 1898 (with a four-story addition on top in 1920). The Bowling Green Building had a coal storage capacity of 420 tons and required 6,000 lights. To its south is the 178-foot-high Washington Building (One Broadway). Built in 1885 and completely remodeled and restyled in 1921, it was also known as the Field Building.

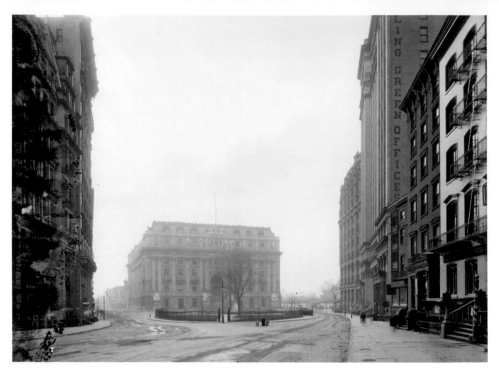

VIEW FROM BOWLING GREEN LOOKING SOUTH: Today, the Custom House building is dwarfed by the skyscrapers behind it, but when it was built, it dominated the view looking south from just north of Bowling Green. The park looks much more inviting these days, with more trees, and the farm stand booths that are often set up on the southeastern side of the park.

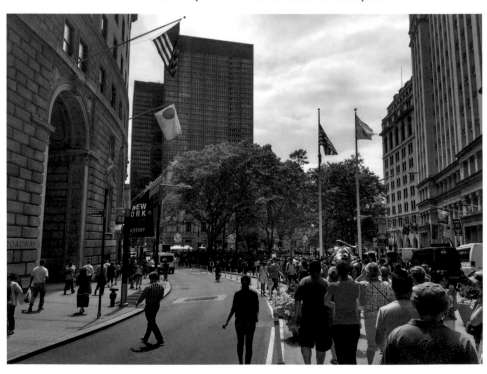

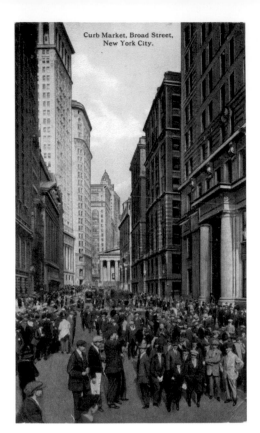

Curb Market, Broad Street, New York City.

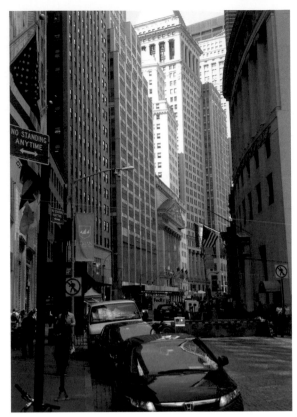

BROAD STREET: One of the city's oldest streets, Broad Street is a typical financial district street, a narrow canyon surrounded on both sides by skyscrapers. The New York Stock Exchange building is visible in distance on the left side of the street on this view looking north. The street is on the site of what was originally Broad Canal in the 17th century, and extends from Wall Street all the way to the southern tip of Manhattan, one block east of the Staten Island Ferry Terminal.

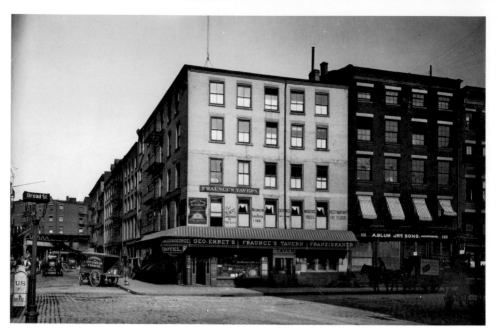

FRAUNCES TAVERN: Originally built in 1719, this building had various uses in its first several decades of existence. It was used as a dancing school, and then housed merchants before becoming a tavern in 1762. This "Queen's Head Tavern" gained fame decades later when General George Washington bade farewell to his officers there in December 1783, after the Revolutionary War was over and a week after Evacuation Day. In the Long Room of the tavern, Washington said to his officers: "With a heart full of love and gratitude I now take leave of you. I most devoutly wish that your latter days may be as prosperous and happy as your former ones have been glorious and honorable." The building deteriorated over the course of the 19th century and was reconstructed (not authentically) in the late 19th century (as seen above). In 1907, a reconstruction was completed that was faithful to the original.

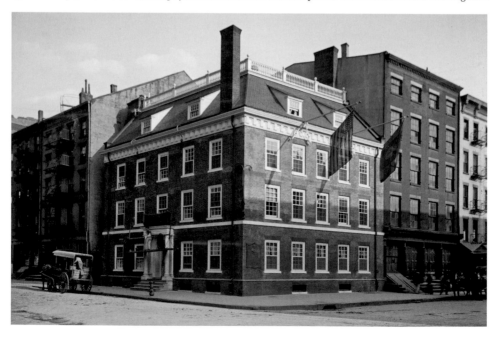

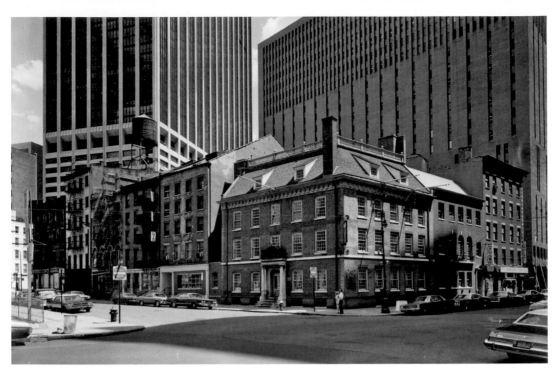

FRAUNCES TAVERN: Though the present-day version of Fraunces Tavern looks authentic and matches the style of the original, it is mainly 20th century construction and only used a few scant pieces of the remaining original building. Though it is a NYC Landmark, it is not an 18th century building, but rather a reconstruction of one. It houses a restaurant and museum.

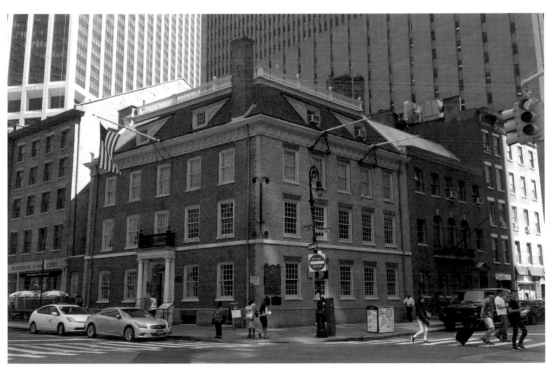

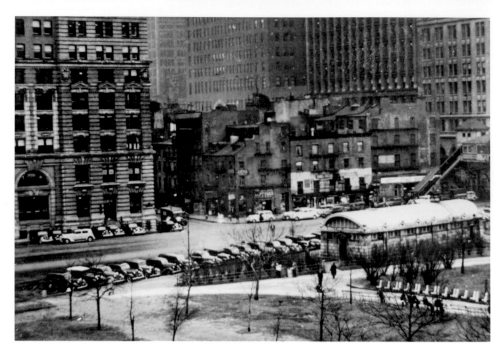

BATTERY PLACE BUILDINGS: The old 19th century buildings seen in the mid-1930s were later replaced by the Brooklyn Battery Tunnel ventilation building, the construction for which began in the 1940s. The tunnel opened in 1950. The ventilation building gained worldwide attention as the filming location for the Men in Black's headquarters in the original 1997 film starring Will Smith and Tommy Lee Jones. Hurricane Sandy flooded the tunnel (which was renamed the Hugh L. Carey Tunnel just a week before the storm hit) in 2012 and it took two weeks to remove all the water and reopen the tunnel.

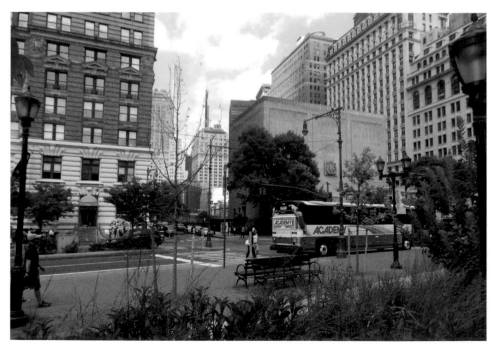

THE JAMES WATSON HOUSE AND THE CHURCH OF OUR LADY OF THE ROSARY:

Facing Battery Park on State Street are two historic structures. The building at 8 State Street (left) was formerly the home of St. Elizabeth Ann Seton between 1801 and 1803. Seton was the first American-born person to become a saint. The badly deteriorated Seton home was demolished in the 1960s and the Church of Our Lady of the Rosary erected in its place in 1964. The James Watson house (right; at 7 State Street and built in 1793), also deteriorated, was given a major rehabilitation, and is and is now the shrine for St. Elizabeth Ann Seton. Both addresses used to be home to the Irish Mission for Immigrant Girls, founded during the 1880s. The Mission provided assistance to more than 100,000 Irish girls.

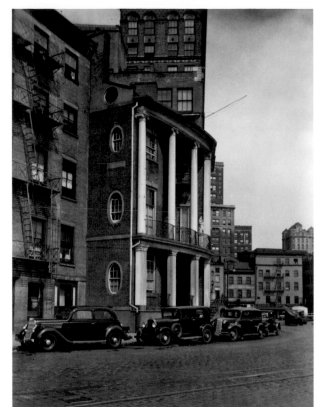

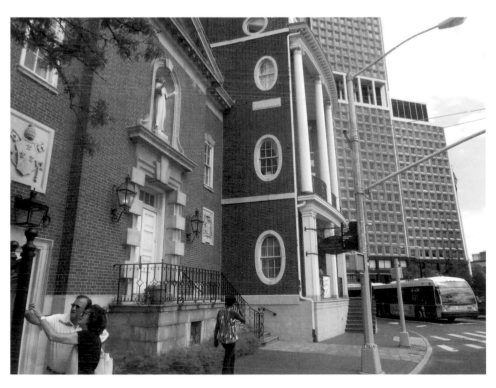

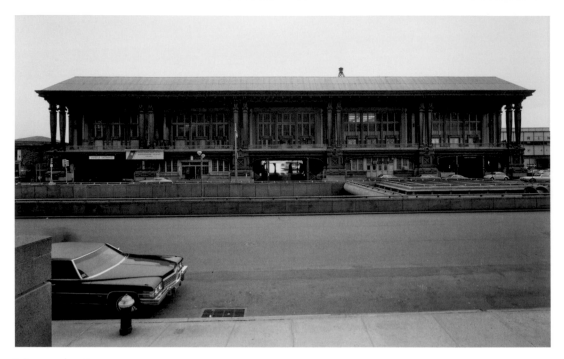

WHITEHALL FERRY TERMINAL: This 250-foot-long historic structure at 11 South Street (designed by Richard Walker and Charles Morris in the Beaux Arts style) was built in 1909 as the Municipal Ferry Pier. It was built largely from cast and wrought iron. It is now known as the Battery Maritime Building, and it serves as the Manhattan terminal for ferry connections to Brooklyn, just as it did when first built, though there was a decades-long gap when the building, which also serves as a departure point for seasonal rides to Governor's Island, sat deteriorating. It underwent a $60 million restoration between 2001 and 2006.

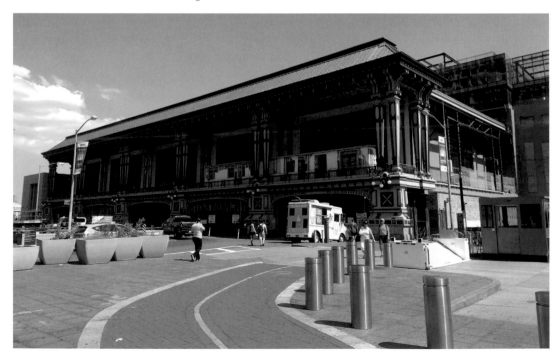

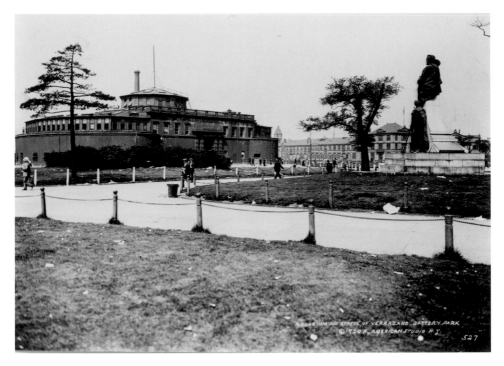

GIOVANNI DA VERRAZANO STATUE: The imposing statue that stands in Battery Park was a gift to the city of New York from Charles Barsotti, the editor of an Italian American newspaper, *Il Progresso*. It dates to 1909, though its original pedestal was replaced in 1951 due to vandalism, and the part of Verrazano's cloak that draped over the top of the base was also removed along with it. The sculptor was an Italian artist named Ettore Ximenes.

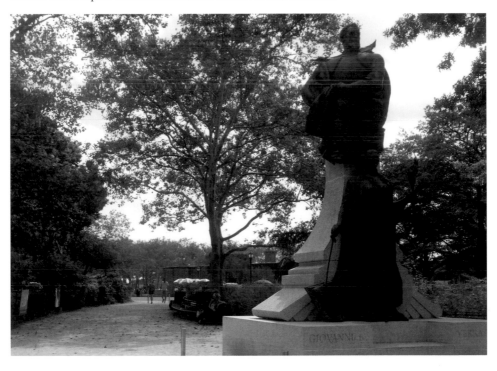

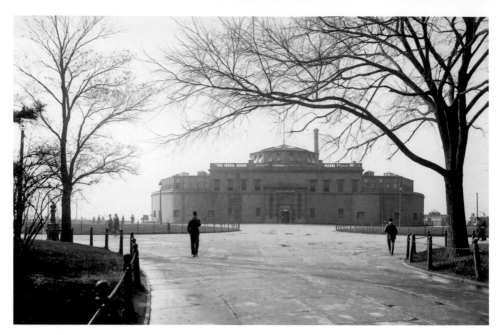

CASTLE CLINTON: This structure, located in Battery Park, has had a long and storied history. It was originally constructed between 1808-1811 as Castle Clinton, a fort designed to protect New York from the British during a time of growing hostilities preceding the War of 1812. In 1823, the fort was given to New York City and in 1824 it was reinvented as an entertainment complex called Castle Garden. A roof was added during the 1840s. The famed Swedish singer Jenny Lind made her American debut here. In 1855, the site was reinvented again as an immigration center. Millions of immigrants passed through here before Ells Island opened. In 1896, it became the New York City Aquarium. When the aquarium relocated to Coney Island in 1941, the structure was almost demolished. It was saved and restored back to its original appearance as a fort.

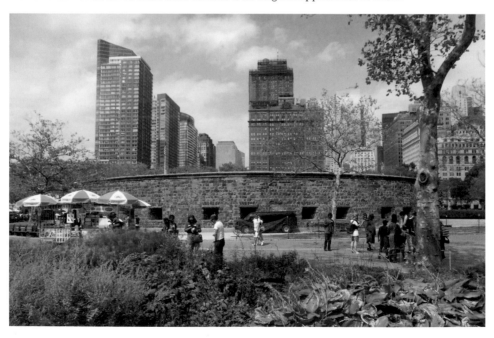

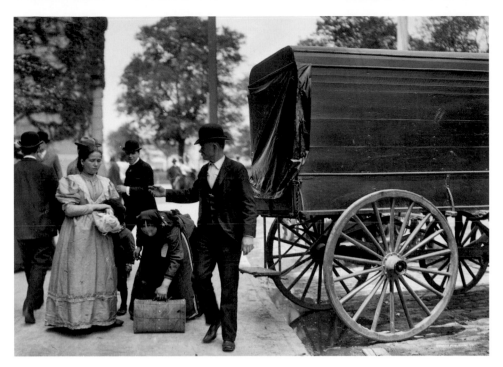

BATTERY PARK IMMIGRANTS AND TOURISTS: Because the immigration station known as Castle Garden was located at the Battery, and then Ellis Island in the harbor just south of the Battery, immigrants were a common sight at the southern tip of Manhattan for many decades starting in the 1850s. These days, you are still likely to see people from other countries at the Battery, but now they are usually tourists who are on their way to or from visiting the Statue of Liberty.

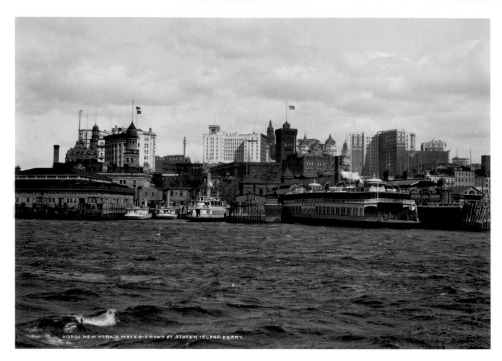

THE STATEN ISLAND FERRY: The first ferry between Manhattan and Staten Island was a private enterprise when it began in the 18th century. It remained that way through the end of the 19th century. A deadly accident in 1901 was the impetus for the City of New York to assume control of the ferry operation. These days, the Staten Island Ferry transports 22 million passengers every year on the five-mile, 25-minute ride. On weekdays, boats make 109 daily trips between Manhattan and Staten Island.

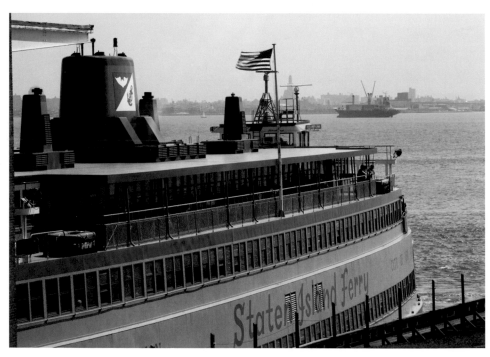

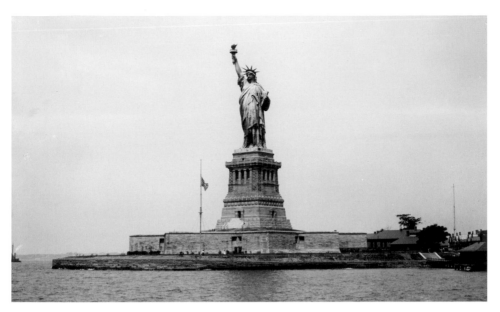

STATUE OF LIBERTY: A gift from France in the 1880s, work on the Statue of Liberty began in 1871. Once the pieces were cast, they were transported to the United States in crates and assembled on Bedloe's Island (Liberty Island) under the supervision of an army engineer named Charles Stone. The statue was designed by Frederic Bartholdi and engineered by Gustave Eiffel (the engineer of the Eiffel Tower). Its final height was 306 feet from the base of the pedestal to the tip of her torch. When completed it was one of the highest man-made points in New York. The statue is one of the most impressive and popular structures in the entire New York metropolitan area. It is located a little under two miles south of Battery Park. The statue was closed for a $62 million restoration in 1984 and reopened in 1986 in time for its 100th anniversary. Liberty Island was closed for security reasons for nearly three years following the attacks on September 11, 2001, and finally reopened in 2004.

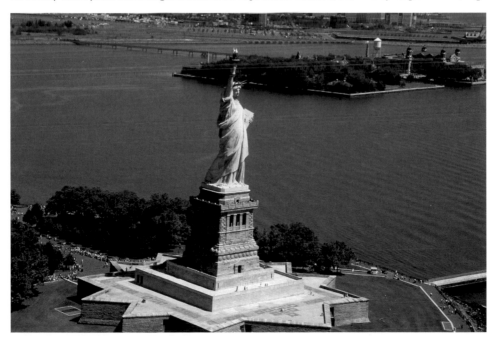

ACKNOWLEDGMENTS

All vintage images are from the Library of Congress, Prints and Photographs Division, except for those on the following pages, which are from the author's personal collection: 58, 75, 85.

All new images are mine, except for those on the following pages, which are from the Library of Congress, Carol Highsmith Collection: 58, 79, 94, 95

Thanks to all my friends and family for their continued support. I walked 25 miles through Lower Manhattan over several days, in the course of taking the photos in this book. It was exhausting but fun. As I walked the city streets, camera in hand, it was thoughts of my loyal supporters that propelled me onward. You were right alongside me in the summer sunshine, marveling at the wonders of Lower Manhattan. Thanks also to Alan Sutton and the editors at Fonthill Media.